E
IC

TYP
SPECIF

RotoVision

ISBN: 2-88046-820-5

ART DIRECTOR
LUKE HERRIOTT
ROTOVISION

DESIGN
LOEWY, LONDON
+44 (0)20 7798 2098

PHOTOGRAPHY
XAVIER YOUNG

REPROGRAPHICS AND PRINTING IN
SINGAPORE BY PROVISION PTE.
TEL: +65 6334 7720
FAX: +65 6334 7721

A ROTOVISION BOOK

PUBLISHED AND
DISTRIBUTED BY
ROTOVISION SA
ROUTE SUISSE 9
CH-1295 MIES
SWITZERLAND

ROTOVISION SA
SALES AND EDITORIAL OFFICE
SHERIDAN HOUSE
114 WESTERN ROAD
HOVE
BN3 1DD
UK

TEL: +44 (0)1273 72 72 68
FAX: +44 (0)1273 72 72 69
WWW.ROTOVISION.COM

10 9 8 7 6 5 4 3 2 1

TYPE
DESIGNING CUSTOM FONTS FOR FUNCTION AND IDENTITY

SPECIFIC
CHARLOTTE RIVERS

ENTS

AABCDEFG
HIJJKKLM
NNOOPQQ
RRSTUUVV
WXXYYZ
1234567890

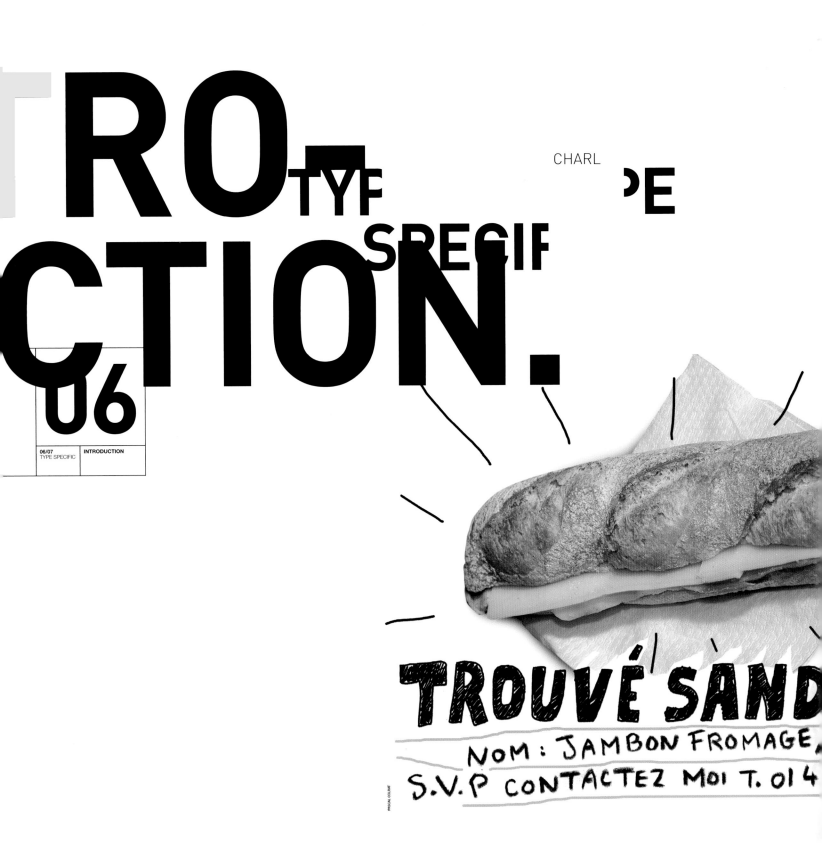

TRO TYF CHARL PE

CTION. SPECIF

06

TROUVÉ SAND

NOM : JAMBON FROMAGE,

S.V.P CONTACTEZ MOI T. 014

PASCAL COLRAT

INTRODUCTION

IN1
DU

OTTE RIVERS

FIC

As we go about our everyday lives, we are completely surrounded by type and typography. It is everywhere. On signage it directs us, in instructions it helps us, through advertising it influences us, on packaging it describes to us, and through books and magazines it informs us, tells us stories, and educates us. It forms a fundamental part of our existence and, of course, a fundamental part of graphic design. In this context, type's central function is to communicate a message in such a way that firstly, the intellectual content is understood, and secondly, it is given a unique "voice."

Essentially, typefaces are an artful representation of words. Each is unique, and in a sense each has a personality. Today there are so many typefaces in existence, it would be virtually impossible to put a figure on it. Things have changed dramatically since the days of hot-metal type when skilled typographers devoted themselves to their craft. Today font design and typography is no longer restricted to those specialized craftsmen in fully equipped workshops. Access to a huge range of fonts, and to programs for font design, is open to anyone in a computerized office or home. The advent of computers in the 1980s meant that people were not only introduced to the wide variety and use of different typefaces available through desktop publishing (a basic word processing program comes with over 60 different typefaces), it also meant that designers were introduced to programs like Fontographer, which enabled them to create custom typefaces easily and quickly.

It is perhaps because of this that, despite the bewildering amount of typefaces available, designers will often create a custom font to suit a particular need. Sometimes it will be a tweaked version of an existing typeface, other times it will be a completely new design. Sometimes only the letters needed (say for a logo) will be created, other times a whole font family will be created. In a commercial world obsessed with branding, a custom font can be the most efficient and effective way to create a unique identity, and increasingly, companies are commissioning unique fonts for use on their packaging and promotional materials.

The history of typography, beginning with ancient Egyptian hieroglyphs and through centuries of printing in the Far East, is a subject worthy of a book in its own right. For the purposes of this book we will explore only what is commonly referred to as the history of modern type. This begins in the fifteenth century, and its invention is credited to German Johannes Gutenberg and his celebrated *42-line Bible*, published circa 1444. It was around this time that the Old Style, or Antiqua typefaces were developed (among them Garamond) from their predecessor, Old English. Old English was highly decorative and complex which meant that it was both difficult to write and read; with the invention of printing and the consequent advancement of society, it was also impractical.

Old Style typefaces were prevalent throughout the fifteenth and sixteenth centuries, but by the end of the seventeenth, a new style of typeface was emerging, and by the beginning of the eighteenth, one of the best-known and most widely used typefaces in the world—Times Roman—was created, along with other popular faces including Baskerville. Known as Transitional typefaces, they have a higher level of contrast and a more austere sense of design than the Old Style faces. They sit well on the typography timeline between the ornate, organic nature of Old Style faces and the minimalist nature of the Modern fonts.

By the end of the nineteenth century, a more dramatic change was occurring with the creation of sans-serif typefaces. The serifs at the end of strokes were dropped and typefaces became more linear, but they weren't an instant hit; initially called Grotesque typefaces, they were only really used in advertising. It wasn't until the early 1900s (the 1920s and 1930s in particular) that they became popular. Eric Gill was one of the main characters in their development, creating the first highly influential sans-serif typeface, Gill Sans. This helped to bring on a surge in the popularity of sans-serif faces throughout the twentieth century. Paul Renner was another important character. In 1928 he created Futura, and following the introduction of this, sans-serif faces became the mainstream type style. It was at this time that Jan Tschichold sparked controversy with his much publicized *The New Typography: A Handbook for Modern Designers*, first published in 1928. According to Tschichold, "A good letter is one that expresses itself, or rather 'speaks,' with the utmost distinctiveness and clarity. And a good typeface has no purpose beyond being of the highest clarity." However, despite Futura "leading the way," it was superceded by Helvetica which became the "must use" sans-serif face of the century for many designers and remains very popular today.

The latter half of the twentieth century saw a huge growth in type foundries, with designers making the most of the opportunities that the new computer technology provided. In the same year that the Macintosh computer was first introduced—1984—Rudy VanderLans founded Émigré, a digital type foundry and publisher of the design journal *Émigré*. It continues to be recognized as one of the leading innovators in the fields of graphic and experimental font design, and its library now houses over 300 typefaces, created by a number of contemporary designers. Another such foundry is FontShop International. This was founded in Germany in 1989 by Erik and Joan Spiekermann; it now houses over 3,000 typefaces. Spiekermann is famed for his more "humanist" take on the sans-serif typeface with his creation of the highly popular Meta, developed in 1993.

Another leading innovator of the late twentieth century was Carlos Segura who, in 1994, founded the T.26 Digital Type Foundry in Chicago. This foundry has created such faces as Euphoric, Boxspring, and Peepod and continues to be at the forefront of typeface design today. Other leading lights include Jeremy Tankard and Jonathan Barnbrook. Having previously worked for design firms Wolff Olins, and Addison Design Consultants, London, as a graphic designer and typographer, Tankard founded Jeremy Tankard Typography in 1998 to pursue his own design ambitions. His fluid Adobe Original typeface Blue Island won a Type Directors Club Type Design Competition 2000 Award; among his other typefaces are Disturbance, Bliss, Enigma, Shaker, and The Shire Types (a collection of six typefaces taking their names from England's midland counties). Barnbrook founded Virus in 1998, releasing such fonts as Bastard and Prozac. As a graphic designer he has collaborated with artist Damien Hirst on the book *I Want to Spend the Rest of My Life Everywhere, With Everyone, One to One, Always, Forever, Now*, and is also known for the design of the book *Typography Now Two: Implosion*, as well as high-profile advertising campaigns.

Over the past 20 or so years, thousands of typefaces have been created, some completely from scratch, many adapted from older typefaces, but all developed largely using the Mac and other computer technology. Without doubt, technology has dramatically changed the way the whole typeface design industry works. As Émigré's Web site points out, this has faced the art and craft of typeface design with the danger of becoming extinct due to the illegal proliferation of font software and general disregard for proper licensing etiquette—typeface developers have campaigned for greater action to be taken against those who illegally copy typefaces for years. However, much genuine typeface design does still exist and the industry is looking healthier than ever with exciting, experimental, and innovative type design being created in every corner of the world. The development of type and its recognition as an art has been given a massive boost by the increase in general awareness of typefaces that DTP and programs like Fontographer have brought about. An awareness and understanding of type design is now open to anyone who uses a Mac or PC.

Charlotte Rivers

SKINCIL
PATRICK DUFFY

BILLBOARDS FOR PARIS BIENNALE
STEFAN SAGMEISTER

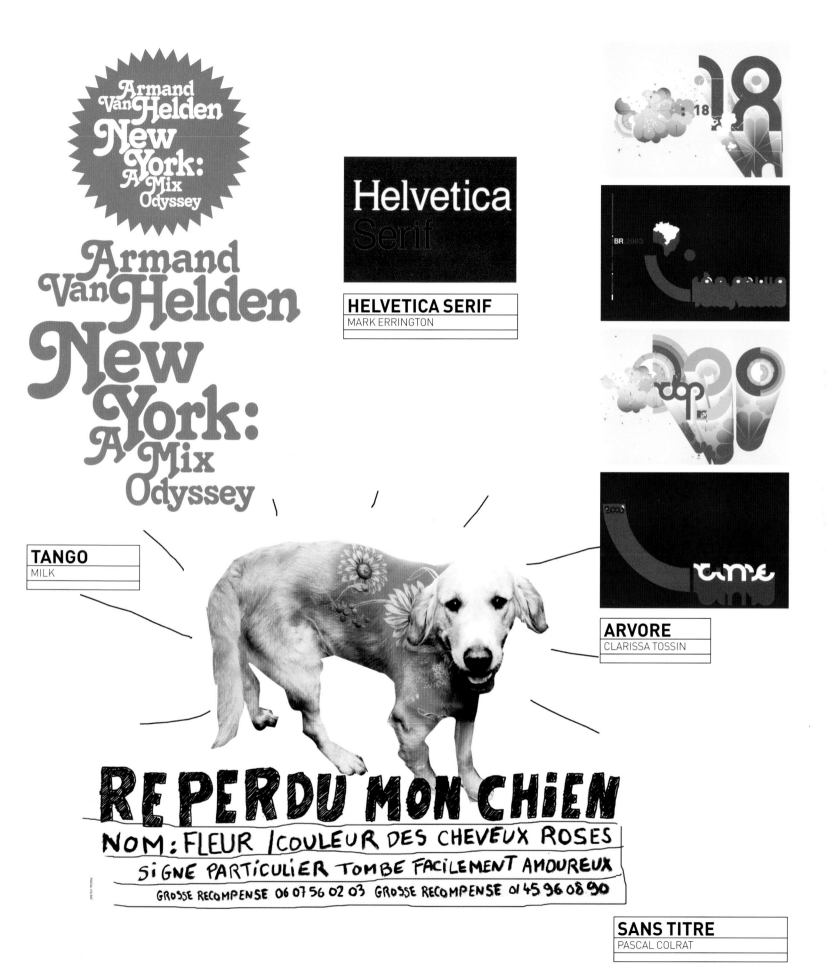

NEWS
AND
MAGAZINE

10

CHAPTER 01:
NEWSPAPERS
AND MAGAZINES

SPAPERS

Things have moved on since the early days of newspapers, when they were printed black-and-white, using hot-metal typesetting and letterpress printing. Today, printers use computer typesetting and offset lithography in color. The considerations for designers remain the same though; a font for a newspaper has to work as a headline font or as body text, and remain distinct when printed on such highly absorbent paper.

Typefaces for use within magazines are very different from those used for newspapers simply because the magazine environment allows for more varied and experimental faces. A magazine's masthead functions as its logo; it must be easily distinguished, unique, and work as the visual voice of the magazine.

This chapter includes designs that successfully meet the need for economy and legibility.

The *Houston Chronicle* is the major daily newspaper in Houston, Texas, and is the U.S.A.'s seventh largest daily paper and tenth largest Sunday paper. The paper had been living with its design since the early days of PostScript, working only with the typefaces that were available in the mid-1980s. Using visual elements and a typographic palette very typical of its era, it was not that distinctive. Headlines were in Times New Roman and Franklin Gothic, text was in Corona, Helvetica, and Trajan, with Goudy Old Style in feature sections.

Jeff Cohen, the new Editor-in-Chief, was looking for a fresh new look from top to bottom. In 2003 Roger Black, the design consultant brought in to steer the redesign, commissioned Christian Schwartz at Orange Italic to draw a headline face. However, as the project progressed, a body-text face grew almost unintentionally.

Inspired by the fact that the Chronicle is owned by the Hearst Corporation, Roger looked back to the restless energy of the Hearst papers, including the *San Francisco Examiner* and *New York Journal*, from the early twentieth century. He noticed various incarnations of Jenson Old Style, and other bold, clunky serif faces in the same genre. Popular for headlines until about the 1920s, Roger felt that Jenson faces were ripe for a rediscovery. He tried British Monotype's Italian Old Style for headlines in a prototype as proof of this concept. It worked well, and Schwartz was called in to revive it as a proper news face.

The main requirements for Schwartz's design were that the typeface be more readable than the old font, and that it be distinct enough to strengthen the *Houston Chronicle* brand.

12 ORANGE ITALIC

DESIGN

HOUSTON CHRONICLE NEWSPAPER REDESIGN

PROJECT

CHAPTER 01:
NEWSPAPERS
AND MAGAZINES

CONTACT
WWW.ORANGEITALIC.COM

ABCDEFGHIJKLMNOPQRSTUVWXYZ
abcdefghijklmnopqrstuvwxyzßfiflffffiffl
¶§#$£¥ƒ€0123456789%‰¢°ªº=<+−×÷>
¿?¡!&(/)[\]{|}*·,.:;...""''·,,«»‹›_-−—•†‡@®©℗™
áàâäãåæçéèêëíìîïñóòôöõøœúùûüÿ
ÁÀÂÄÃÅÆÇÉÈÊËÍÌÎÏÑÓÒÔÖÕØŒÚÙ

Mother of 3 hunts terrorists at night

■ Montana judge, 6 others use Web to snare suspects

States. In that guise, she combs the Internet through the late evening and early morning and sifts through the messages and declarations on extremist Islamic Web sites.

By EVAN MOORE
HOUSTON CHRONICLE

CONRAD, MONT. — By day, she's the municipal judge of this tiny town, a wife and mother of three, but by moonlight Shannen Rossmiller is a spy.

Then, Rossmiller — petite, blond and 34 — assumes one of several unlikely false identities, all angry, violent, Muslim men, nurturing hatred of the United

During those hours, Rossmiller is on a quest that consumes hours of each day, days of each week. It's one that will place her on the stand Thursday as the government's primary witness against a National Guardsman accused of offering information to help Muslim extremists kill U.S. troops.

It's a quest that has already placed her in danger.

Please see **TERRORISTS,** *Page A4*

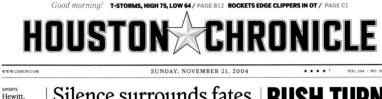

HOUSTON ★ CHRONICLE

WWW.CHRON.COM SUNDAY, NOVEMBER 21, 2004 ★ ★ ★ ★ * VOL. 104 • NO. 39 • $1.75

SPORTS
Hewitt, Federer to meet
Lleyton Hewitt beat Andy Roddick on Saturday and will take on Roger Federer today in the ATP Masters Cup final. Federer defeated Marat Safin to advance.
PAGE C1

COLLEGE FOOTBALL
Oklahoma shuts down Baylor 35-0
Louisville 65
Houston 27
Auburn 21
Alabama 13
SPECIAL SECTION, PAGES F1-4

BUSINESS
Good news for retailers and parents
Even though there's no must-have toy this year to frustrate parents, retailers are expecting a 4.5 percent jump in overall holiday sales over last year.
PAGE D1

EDITOR'S CHOICE
Hollywood gets serious
This week marks the beginning of the Academy Award season as Alexander and Kinsey hit screens. We preview all the major releases.
ZEST

GOODFELLOWS
In need of basic comforts
Katriece Stapleton needs two beds, bedding and clothing for her two asthmatic children.
PAGE B3

INSIDE
Barry 64
Business D1
City & State B1
Crossword G4
Dear Abby G2
Directory A6
Editorials E2
Hoffman ZEST
Horoscope G4
Lottery B2
Movies ZEST
Obituaries B9
Outlook E1
Sports C1
Star G1
Travel J1

Silence surrounds fates of contractors in Iraq

■ **Some companies won't say exactly how, or how many, workers have died**

By DAVID IVANOVICH
HOUSTON CHRONICLE

WASHINGTON — Halliburton Co. truck drivers Tim Bell and Bill Bradley disappeared April 9 when their convoy was attacked west of Baghdad.

Did they die at the scene? Were they captured? Is there reason for hope?

No one will say.

Like those of many contractors caught in the violence of Iraq, their fates are shrouded in mystery.

INSIDE
Insurgents assassinate three Iraqi officials. **PAGE A23**

The Army has conducted an investigation into the ambush, but the report is classified. Pentagon officials refused to discuss its contents, directing questions to Halliburton. The company referred questions back to the Pentagon.

"We have done everything in our power to find information and found that we are hitting a brick wall," Bradley's family wrote in an e-mail to the Houston Chronicle.

"We are crushed."

The military has turned heavily to private contractors to *Please see* **CASUALTIES**, *Page A18*

ESCAPED: Former Iraqi hostage Tommy Hamill has co-written a book about his experiences.

BUSH TURNS UP THE HEAT ON N. KOREA

■ **Russian, Asian leaders back U.S. on nuclear issue**

By BENNETT ROTH
HOUSTON CHRONICLE

SANTIAGO, CHILE — Putting security threats at the top of his agenda, President Bush on Saturday won commitments from Russian and Asian leaders to press the North Koreans to eliminate their nuclear weapons programs.

Bush, who met with leaders during a Pacific Rim trade summit here, suggested he heard no dissent from his stand that North Korea must complete negotiations with Washington, Russia, Japan, South Korea and China to dismantle its nuclear programs.

"The leader of North Korea will hear a common voice," said Bush, after meeting with Japanese Prime Minister Junichiro Koizumi.

Bush also met with Chinese President Hu Jintao, who said he wanted to resolve the nuclear standoff on the Korean peninsula peacefully, and with South Korean President Ro Moo-hyun, who supported the six-nation negotiations.

Bush was more blunt in his warning to North Korea's leader, Kim Jong Il, in remarks to business leaders at the Asia-Pacific Economic Cooperation forum. He told them that "the will is strong, that the effort is united, and the message is clear to Mr. Kim Jong Il: Get rid of your nuclear weapons programs."

In remarks to business leaders, Bush pledged to continue his free-trade policies and work to reduce U.S. government deficit, which ballooned during his first term.

But the threat of nuclear weapons proliferation in North Korea as well as Iran was the top issue during Bush's private meetings during the 21-nation APEC forum, where trade and terrorism are also on the agenda. Also hovering in the background was the continuing con-
Please see **SUMMIT**, *Page A21*

Spending measure OK minus provision

■ **Senators reject power to examine tax returns; NASA given a boost in its funding**

By GEBE MARTINEZ
WASHINGTON BUREAU

WASHINGTON — Legislation that would let top congressional appropriators examine Americans' income tax returns caused delay Saturday in final enactment of a huge $388 billion domestic spending bill.

The House and Senate finally approved the spending measure, which will boost NASA funding to more than $16 billion, but not before Republicans and Democrats in the Senate, who were outraged about the income tax provision, attached a resolution to negate it.

The provision was inserted in the bill by House negotiators, and the House had earlier passed it 344-51.

The Senate finally passed the bill 65-30 but will not send it back to the House until members make an unscheduled return to Capitol Hill on Wednesday to correct the language concerning the IRS provision.

The bill will then go to the president.

"It's not my fault," said Senate Appropriations Committee
Please see **SPENDING**, *Page A14*

Shoving matches made for nasty football, and the Pacers-Pistons brawl with fans marked one of the lowest points in sports history

The week of lost control

UGLY SCENE: Pacers head coach Rick Carlisle and official Tommy Nunez Jr. separate Detroit Pistons players from Ron Artest of the Indiana Pacers at Friday's game in Auburn Hills, Mich.
ALLEN EINSTEIN / GETTY IMAGES

By DAVID BARRON
HOUSTON CHRONICLE

The week in sports began last Sunday in Pittsburgh, where Steelers linebacker Joey Porter and Cleveland Browns running back William Green were ejected from the Steelers-Browns game after exchanging screams and shoves — not in the heat of battle but 45 minutes before kickoff.

It sailed into the weekend Friday night in Auburn Hills, Mich., where an on-court exchange between Ben Wallace of the Detroit Pistons and Ron Artest of the Indiana Pacers escalated into a bottle-throwing brawl between players and fans that resulted in five injuries and the indefinite suspension Saturday of four players.

It ended Saturday in Clemson, S.C., where the South Carolina Gamecocks commemorated Lou Holtz's final game as head coach with a bench-clearing, helmet-swinging brawl between South Carolina players and the Clemson Tigers.

Today begins a new week and a new slate of games.

And for this, presumably, we are supposed to be thankful.

In fact, the Thanksgiving holiday week begins with anger, confusion, investigations and disgust at the latest outburst of violence involving fans and players in college and pro sports.

"Winston Churchill once said, 'This is one of those cases where the imagination is baffled by the facts,'" Indiana coach Rick Carlisle said Saturday. "That's kind of where I am on the whole thing."

Even a veteran NBA observer such as Carlisle couldn't comprehend the 10 minutes of fury that erupted in suburban Detroit — first between Wallace and Artest, then between Artest and fellow Pacers Stephen Jackson and Jermaine O'Neal and the Pistons fans who threw punches, bottles, popcorn, at least one chair and other debris after Artest went into the stands to confront a fan who threw a water bottle at him.
Please see **FIGHTING**, *Page A14*

PREVIOUS PLAYER-FAN CONFRONTATIONS

SEPT. 13, 2004: Texas Rangers relief pitcher Frank Francisco throws a chair into the crowd in Oakland, Calif., striking a woman. He is suspended for the rest of the season and faces a misdemeanor assault charge.
ASSOCIATED PRESS

MARCH 29, 2001: Tie Domi of the Toronto Maple Leafs punches a heckler who falls into the penalty box after the glass partition breaks in Philadelphia. The man claims he was trying to grab a bottle Domi was using to spray water on fans.
ASSOCIATED PRESS

FEB. 6, 1995: The Rockets' Vernon Maxwell runs into the stands during a game in Portland, Ore., and punches a fan in the jaw. He is suspended 10 games without pay and fined $20,000. He leaves the team before the end of the season.
ASSOCIATED PRESS

COMPLETE LIST, PAGE A14

Reaction to the rumble

Friday's brawl was a hot topic with the Rockets. They are sympathetic but don't excuse the players' actions. Neither does columnist John P. Lopez. **STORIES ON C1**

FEATURES AND CONSIDERATIONS ↙

Ascenders – Short in both headline and text versions because newspapers are stringent with leading: they always have a lot of text to pack onto ever-shrinking pages.

Descenders – These were kept short for the same reason as the ascenders.

Counterforms – Fairly open, helped by the Old Style (angled) stress, which moves the weight.

SOLUTION

"I enjoy drawing newspaper types because there are both technical and cultural restraints," explains Schwartz. "Legibility is key because typography is the foundation of a newspaper. Maximizing legibility in spite of very poor printing conditions is not easy. Culturally, readers in different places have different feelings about what sort of type is comfortable for reading their news every day. These are both big reasons why so many newspapers commission custom typefaces.

"He [Cohen] asked me to draw a halfway point. Between Italian Old Style and Bookman was the target, the former because its quirky forms would give a distinctive feel to the paper, and the latter because its contrast and weight are very well suited to news headlines. *The New York Times* used it for over 50 years."

A newspaper font needs to be heavy enough to have a good presence on the page, but not so heavy that every headline "screams," and a low contrast prevents the type from looking too fussy.

The idea was to develop this into a small family, in two weights, with italics, and the italics were to include a set of alternate lowercase characters. The paper had originally planned to use a chunky version of Linotype Ionic No. 5 for the body text, but, unaware of this, Schwartz adapted Houston Headline for it. A press test showed that Schwartz's typeface, now known as Houston, was easier to read than both the Ionic No. 5 and the Corona they had been using for 20 years, so they went ahead with the creation of two weights of text, with italics and small caps.

The headline face needed to walk a fine line between adding a distinctive voice to the paper and being transparent enough to look appropriate for any kind of story. The text face had to maintain the same character as the headline face but, more importantly, reproduce well on the presses.

"I approached it as an adaptation, trying to draw an identifiable revival of Italian Old Style that made all of the concessions necessary to be a credible news typeface," explains Schwartz. "In the headline face, this meant toning down the huge 'bell-bottom' serifs, but leaving details like the inner serifs of the capital M and N, and the angled crossbar of the lowercase e intact. In the text face, this meant trimming off these extra serifs to open up counterforms; straightening out the crossbar of the e, because it was distracting; and widening the italic, to keep the counterforms from getting too narrow." All of these amendments made the text face more readable. It was also important that the typeface worked on the paper's presses, so three or four rounds of press tests were printed to make sure it worked in the way it was intended. A lot of small white spaces—for example, the counters in the lowercase a, w, and x—had to be exaggerated to make sure they didn't fill up with ink.

I'M
TIRED OF
BEING THE
FUNNIEST
PERSON
IN THE
ROOM

SOLUTION

Completed in 2003, the issue is a homage to the famous "windy city," including articles and stories about life in the great metropolis. Since all other aspects of the issue were devoted to Chicago, Seeger and Shachter felt it was only right that the type should be as well. Over 15 typefaces of the late Midwestern typographer Robert Hunter Middleton were utilized for the magazine, along with a few customized treatments created specifically for this issue of the magazine.

14

DESIGN
HANS SEEGER AND JOHN SHACHTER

PROJECT
BIG MAGAZINE CHICAGO EDITION

14
TYPE SPECIFIC

CHAPTER 01:
NEWSPAPERS
AND MAGAZINES

CONTACT
HANSSEEGER@EARTHLINK.NET / SHACHTER@SBCGLOBAL.NET

BRIEF

Big is an international style magazine recognized in the industry as a title that covers the latest visual and cultural trends with stunning design and informative content. It also has a history of great collaborations. Conceived in Spain over 10 years ago, it has since been published in different countries, with each issue focusing on a single topic. In 2002, Chicago-based designers Hans Seeger and John Shachter were asked to design, art direct, and edit an issue devoted to the city of Chicago.

SOME
PEOPLE
DON'T
GET THE
BLUES

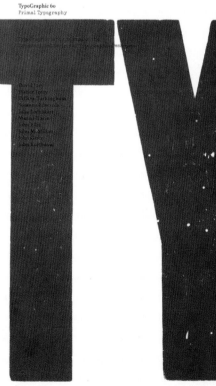

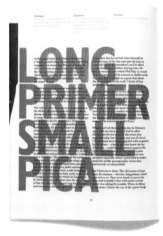

BRIEF

The International Society of Typographic Designers (ISTD) is the widely known professional organization for designers and typographers in the U.K. Three times a year, it publishes *TypoGraphic*, a typography journal edited by David Jury, a council member of the ISTD. Issue 60, published in 2003, features several essays relating to analog and digital design and printing processes and carries the subtitle *Primal Typography*.

Designers Scott Williams and Henrik Kubel at A2-GRAPHICS/SW/HK were commissioned to design this issue with an open brief, although the Letter paper (A4) format was fixed, and there was only a small production budget.

SOLUTION

Commissioned in 2002 and completed one year later, the inspiration for the design of this 64-page publication, and the three typefaces created specifically for it, was the subtitle of the journal— *Primal Typography*—and the key essay, "The Codex Project." The journal consists of eight interleaved eight-page sections, each alternating coated and uncoated papers, printed offset litho and then overprinted by letterpress, both wood and metal. When wood type appears it is printed wood type on the actual page—you can feel how the ink "sits" on the page. All other sections are printed with digitally produced typefaces. Nothing has been scanned and then printed, as is common practice with wood print these days.

The three digital typefaces—A2-Merlin Carpenter, A2-TypoGraphic regular and italic, and A2-Typewriter—evolved from hand-drawn sketches. These were transferred into Illustrator to trial different words before the typeface was finished in Fontographer. The letterpress typefaces used are Monotype Caslon (128) (typeset by Stan Lane at Gloucester Typesetting Services), along with a wide selection of wood type.

"WE KNEW THAT WE WANTED TO FIND SOMETHING TO EXPLORE SO THAT WE DIDN'T SET OUT MAKING A RECORD THAT WAS GRABBED RANDOMLY WITHOUT FOCUS AND ENDED UP BEING ABOUT SUZY FROM THE RESTAURANT OR WHATEVER"

IT'S NOT ABOUT ALL
THE
IT'S ABOUT HOW YOU
AND
BRINGING IT ACROSS
THAT WAY

DESIGN
STEREO TYPE HAUS

PROJECT
FADER MAGAZINE HEADLINE FONT

CONTACT
WWW.STEREOTYPEHAUS.COM

16

FA

MA
AT
THE M
AREN'

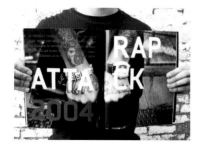

RAP
ATTACK
2004

"EVERYONE'S TIRED OF ALL THAT FUNK SAYS DJ PREMIER. NOT MEOW." "THE MUSIC OUT NOW, OF BBELL-ASS BEATS." "AND I MEAN BEEA-OW."

RISING SONS

NEVER
MIND THE
BOLLOCKS,
HERE'S
THE REAL
UK GARAGE

DER

17

THE FADER MAGAZINE
JULY/AUGUST 2004

PUNK-ASS WITCHES

THREW THEIR FACE IN A TRENCH AND STUCK AN ALBUM ON TOP

MIGHTY!

UNDIVIDED

BRIEF

FADER is an American music, fashion, and culture magazine. Having used Akzidenz Grotesk Bold as a main header face for a number of years, the magazine decided that a change was in order. In the first instance, *FADER* purchased the Stylus typeface family from designers Stereo Type Haus and used it in a few issues before deciding that it should form the basis of the magazine's new look.

RS
ACKS!

RS VOLTA
PLAYING

WWW.THEFADER.COM
US$5.95 CAN$7.95 UK£4.95

17 >

SOLUTION

Designers at Stereo Type Haus began developing the original Stylus faces to better suit the magazine's needs after it was decided that they required a face with more weight—something that was closer to the Akzidenz face it was replacing. It was also important that the typeface conveyed a boldness, because it was to be used as a headline font, and that it had a low cap height, as this is a characteristic of Akzidenz. "Firstly, I took a really good look at the Akzidenz face, its cap height versus weight and so on, and then compared it to the Stylus letters," explains Rick Diaz-Granados, designer at Stereo Type Haus. "I then tried to match the weight and began a visual exploration with specimens and mock layouts similar to what was already in use by *FADER*."

The idea was to create a family that had a similar feel to classic sans-serif faces, but that conveyed a modernist sensibility, and that had more versatility in weights and styles. Diaz-Granados' inspiration came from DIN, a typeface designed by Dutch designer Albert-Jan Pool which he, in turn, had derived from German road signs. Sketches were made in Illustrator before the characters were imported into Fontographer, where further weights and styles were fleshed out.

The font really works well within the pages of the magazine. Mixed with other typefaces on a page, it stands out and does its job as a distinguishable yet subtle and legible headline font. "This was probably one of the most satisfying type projects I've ever completed, not only because of its challenging range, but also because of its visibility in a magazine format," explains Diaz-Granados. "It also allowed me to step back and see how other designers used it and abused it, made good and bad decisions, but more importantly how it functioned and what it conveyed."

ABCDEFGHIJKLMNOPQRSTUVWXYZ
ÅÄÖabcdefghijklmnopqrstuvwxyz
åäö1234567890&$£€%?!üøæñ
+=()¢^»«'´""/@*üøæñ:;#,.´`

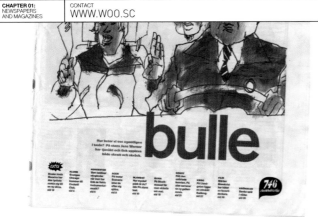

18 DENNIS ERIKSSON WOO AGENCY

PROJECT

DAGENS NYHETER HEADLINE TYPEFACE

CONTACT
WWW.WOO.SC

SOLUTION

Initially, Eriksson created individual letters for use in each of the specific headlines, but as the number required grew, he developed an entire typeface. Eriksson worked on a face that would fit in a comic book–style bubble; something that was slightly rough, off the cuff, clean, clear, easy, and with an element of fun. He first drew the letters by hand, using ink on paper, then scanned and traced the elements of the typeface as images, using Illustrator. Because of its italic feel, the typeface was named Dennis På Stan Italic. The hand-drawn, rough character of the font works well within the context of the newspaper: the coarse texture of the paper throws the typeface into relief against the bold, ink-heavy look of the black bubbles.

BRIEF

Dagens Nyheter is one of Sweden's largest national daily newspapers. In 2001, the paper commissioned illustrator/designer Dennis Eriksson to create a headline typeface with the characteristics of a handmade type. Eriksson had worked with *Dagens Nyheter* before, as an illustrator, and the paper wanted him to apply his illustrative skills to the design of the typeface. The idea was to produce a number of headlines for the various sections in the paper's weekend edition.

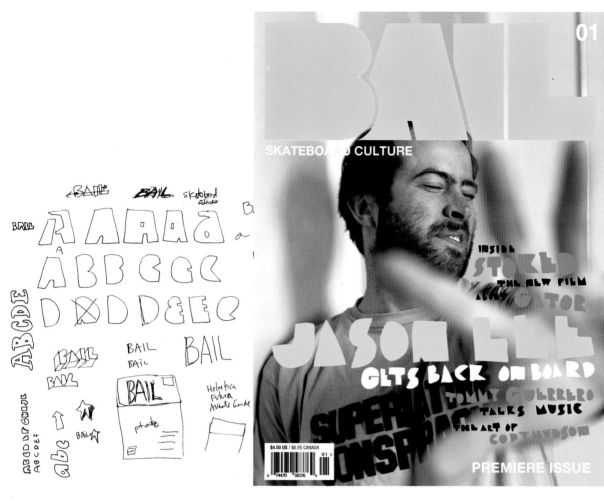

SKATEBOARD CULTURE

INSIDE
STOKED
THE NEW FILM
ABOUT GATOR

JASON LEE
GETS BACK ON BOARD

TOMMY GUERRERO
TALKS MUSIC
THE ART OF
CODY HUDSON

$4.50 US / $6.95 CANADA

01 >

0 74470 58376

PREMIERE ISSUE

beastie
boys
back to
the beat

mofo
snaps back

art for
sterling's sake
beautiful
losers

SOLUTION

Inspired by his passion for offbeat typography from the 1960s, 1970s, and 1980s, Mueller wanted to create something that was unique, and that was bold and visually dominant. He began by working on the overall direction of the magazine design rather than on a typeface; this came about after he started work on the masthead. Mueller liked the direction of this so much, he decided to see if he could extend it into a complete typeface, as he thought it would be good for *Bail* to have an exclusive type.

As Thicky is an extremely bold face, it works best when used in a larger point size, as this avoids any filling in. "It seems to work best when used as a headline," explains Mueller. "The type looks really interesting at a smaller point size, but it becomes hard to read due to the tricky kerning. The kerning seems to be irregular at times, especially when two letters with opposing angles meet—such letterpairs as A and M leave a funny empty space between them. However, after a few modifications—increasing the angle of the diagonal parts in letters, including A and M—Thicky works very well at most sizes.

"It was a great project because *Bail* just let me do my thing," explains Mueller. "I started it like I start most projects—by opening my sketch pad and opening Adobe Illustrator and using both media to start messing with design ideas."

Mueller used analog sketches to help develop some rough ideas of the letter-shapes before moving to computer sketches, in Illustrator, to help refine his ideas. Once the idea was complete, he used Adobe Illustrator to create the final letterforms. Due to time constraints, Mueller asked Nadine Nakanishi and Mike Coleman to help finish designing the numbers for Thicky. Nadine also contributed by turning Thicky into a working font, using Macromedia's Fontographer program.

A B C D E F G H I J K L M N O P Q R S T U V W X Y Z

19
TYPE SPECIFIC

DESIGN

19 OHIO GIRL DESIGN

PROJECT
BAIL MAGAZINE MASTHEAD AND HEADLINE FONT

19
TYPE SPECIFIC | CHAPTER 01:
NEWSPAPERS
AND MAGAZINES

CONTACT
WWW.OHIOGIRL.COM

BRIEF

Independents' Day Media is a U.S.-based, independent publisher of two magazines and a line of books. *Bail* magazine, launched in 2003, was the publisher's follow-up to the long-running *Punk Planet* magazine. *Bail*'s focus is the cultural aspect of skateboarding—the people, the history—as well as celebrating the world around skateboarding—the art, music, politics, and culture that the skate world has spawned. *Bail* aims to set a new standard of skate magazine through in-depth interviews, features, art, and photography. Los Angeles–based designer Andy Mueller, at Ohio Girl Design, was asked to create a typeface to be used as a masthead and headline font in the magazine, as well as on merchandise.

BAIL

SKATEBOARD CULTURE

20 NON-FORMAT

PROJECT
THE WIRE MAGAZINE HEADLINE FONT

20/21
TYPE SPECIFIC

CHAPTER 01:
NEWSPAPERS
AND MAGAZINES

CONTACT
WWW.NON-FORMAT.COM

BRIEF

The Wire is a completely independent music magazine based in London. Scandinavian/British design duo Non-Format are ongoing art directors and designers of the magazine. In 2004, they decided to create a new headline font that would work for all the magazine's features and could run for three or four months.

Drawing inspiration from fonts designed by the modernists of the 1920s, including Josef Albers and Herbert Bayer, designers Jon Forss and Kjell Ekhorn wanted to create a face that was as uncompromisingly idealist as those, but not as restricted by height. They also wanted to inject a "Russian constructivist" esthetic into the magazine; a look that was popular during the early 1980s. The font is based on these simple forms: circle, square, triangle, and rectangle. The first shape created was the square, which was halved to create the rectangle. The equilateral triangle is the same height as the square, and the circle has a diameter equal to the height of the square. A semicircle was created by halving the circle, and another triangle was made by cutting the square in half diagonally.

"We started with the O. That was obviously going to be a filled-in circle. The A was also easily a triangle. Once I had the D shape, the rest of the font came together fairly quickly," explains Forss. "We made the font shapes rise and fall in height so that certain letter combinations became quite dramatic. Even though we had a deliberately restricted choice of shapes, we didn't want to force the font into a box." The A, O, and V were borrowed from early Bauhaus typographic experiments which, nearly a century later, look almost mainstream. However, the designers were keen for the rest of the font to be fairly idiosyncratic, so rather than trying to think in terms of there being a standard x-height for the font, they made it sit on a baseline but ascend to three or four different heights.

Working in Photoshop, the basic shapes were created in separate layers, which the designers could turn on and off to make each lettershape. It was a fast process with only one late addition—small, triangular "cuts" were added to the C and E to refine their legibility. The first version drawn did not have the v-shaped cuts in the C and E. When the designers delivered this, the magazine found that it was not easy to read the headlines.

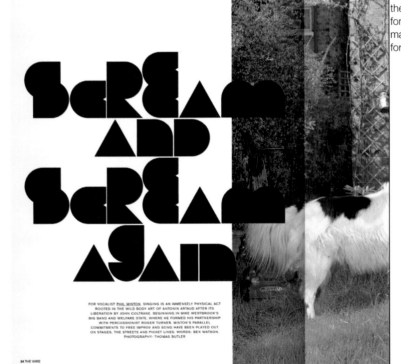

FOR VOCALIST PHIL MINTON, SINGING IS AN IMMENSELY PHYSICAL ACT ROOTED IN THE WILD BODY ART OF ANTONIN ARTAUD AFTER ITS LIBERATION BY JOHN COLTRANE. BEGINNING IN MIKE WESTBROOK'S BIG BAND AND WELFARE STATE, WHERE HE FORMED HIS PARTNERSHIP WITH PERCUSSIONIST ROGER TURNER, MINTON'S PARALLEL COMMITMENTS TO FREE IMPROV AND SONG HAVE BEEN PLAYED OUT ON STAGES, THE STREETS AND PICKET LINES. WORDS: BEN WATSON. PHOTOGRAPHY: THOMAS BUTLER.

34 THE WIRE

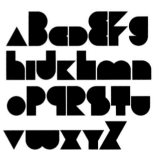

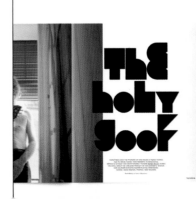

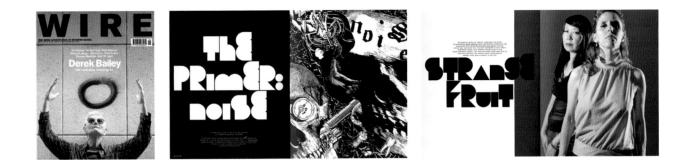

Fire Starter

FROM SWEDISH PUNK
TEEN TO COLLABORATOR
WITH PETER BRÖTZMANN
AND SONIC YOUTH,
SAXOPHONIST
<u>MATS GUSTAFSSON</u> HAS
BUILT UP A FORMIDABLE
DISCOGRAPHY,
MELDING THE EVANGELICAL,
IMPROVISATIONAL
PROPERTIES OF JAZZ WITH
THE RAW, ENGAGING
ENERGY OF ROCK.
NOW WORKING WITH HIS
OWN TRIO, THE THING,
HE EXPLAINS THE JOYS OF
BUYING VINYL BY
THE METRE AND THE
NEED TO "BLOW HARDER"
AGAINST MASS
COMMERCIALISM.
WORDS: ROB YOUNG
PHOTOS: MATTIAS EK

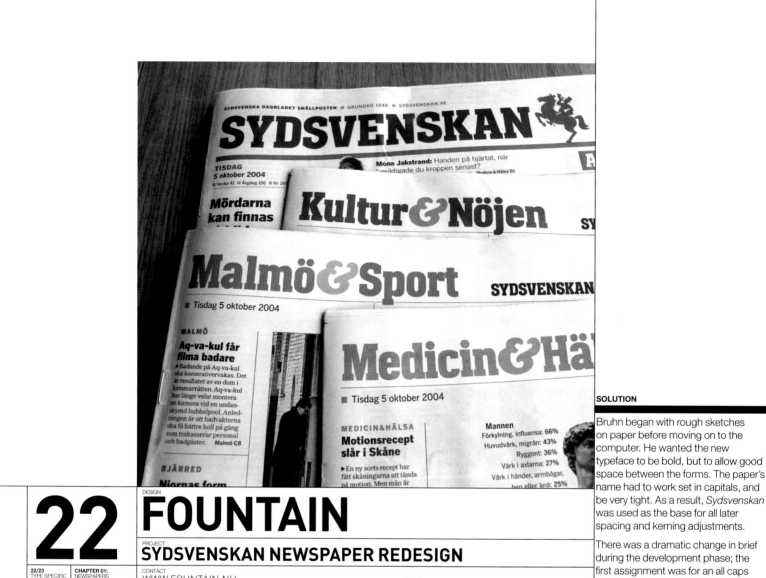

22 FOUNTAIN

SYDSVENSKAN NEWSPAPER REDESIGN

CONTACT
WWW.FOUNTAIN.NU

BRIEF

Sydsvenskan is one of the biggest-selling newspapers in Sweden. In 2004, the paper went through a transformation from broadsheet to tabloid format and also shortened its name from *Sydsvenska Dagbladet* to *Sydsvenskan*. For the revamp it was felt that a new typeface was needed to complement the new look for its main flag and section heads. The previous typeface for the flag was a condensed version of Aachen, but the revision required something more modern to bring the paper into the twenty-first century. The change also had to be "unnoticeable" at first glance—a modest refinement was key in this project. Swedish designer Peter Bruhn, at Fountain, was commissioned to complete the job.

SOLUTION

Bruhn began with rough sketches on paper before moving on to the computer. He wanted the new typeface to be bold, but to allow good space between the forms. The paper's name had to work set in capitals, and be very tight. As a result, *Sydsvenskan* was used as the base for all later spacing and kerning adjustments.

There was a dramatic change in brief during the development phase; the first assignment was for an all caps typeface, but as the project progressed it was decided that lowercase should be used for the section heads. When this decision was made, Bruhn had almost finished the uppercase, so many things had to be rethought, for instance, spacing on the main flag had to be adjusted while maintaining the tightness of the characters.

The x-height on this typeface, named Sydsvenskan after the paper, has been kept high to aid readability, and the "look" of some of the serifs from Aachen were kept, but with straighter brackets connecting them to the stem of the letter. All of the design work was done in Fontographer, before moving into FontLab for finishing.

I Malmö finns det ingen Liten falafel, bara stor Stor & Extra Stor!

Tågen avgår ibland till Köpenhamn

Lindängen - Limhamn 8-2

Im-if-if! Im-if-if! Im-if-if!

LÖSNUMMER & PRENUMERATIONER

Fotbollsfest på Lilla Tor

Vad gör vi nu när kranen är bo

RÖRSJÖSTAD

Vieng Thai på Förenin

Käppas

ᴧAABCDEFG
HIJJKKLM
NNOOPQQ
RRSTUUVV
WXXYYZ
1234567890

DESIGN

24 SUZY WOOD AND PETER STITSON

PROJECT

DAZED & CONFUSED MAGAZINE HEADLINE FONT

CONTACT
WWW.CONFUSED.CO.UK

BRIEF

Dazed & Confused is one of the U.K.'s leading cutting-edge style magazines. Published monthly, the typefaces used change regularly. For the "New York" issue in July 2002, Art Director Suzy Wood and Designer Peter Stitson wanted to create a new headline font as the one they were using didn't convey the right attitude for the issue; it was curvy, with a pop-art look, and a small x-height in lowercase, all of which worked against the more aggressive look they sought. They needed a headline font with a little more presence, something attention grabbing, angular, and hard edged that would better reflect the attitude of the issue.

SOLUTION

Inspired by Rudy Gernriech, Milton Glaser, and New Yorkers featured in the issue, Wood and Stitson created a bold, angular, versatile typeface that has filled characters. The time constraints inherent in producing a monthly magazine meant that the font had to be designed quickly, so having decided on a few key points, basic sketches were made before it went straight to Illustrator. All the headlines were built in Illustrator—there was no time to put it through Fontographer—which gives the face a rawness that adds to its character.

Two or three versions, with fills and without fills, were created for a number of the characters, such as O, K, N, and R, so that the designers could fine-tune coverlines to suit the images they were partnered with, while keeping them as legible as possible: if all the characters of one word have solid fills, it can look pretty clunky and unforgiving.

"Culture moves and mutates so quickly, and *Dazed*'s content reflects this," explains Wood. "Magazines are a good visual resource and you tend to see ideas being recycled in advertising and other media quickly, so creative headline fonts in particular can have a limited life before they no longer stand out. The positive side to this is that you feel constantly challenged to stay fresh, to try and present something interesting within the time constraints."

The font, The New New York, is pretty versatile; the filled characters can be used as picture boxes—a useful way of introducing an image without losing the impact of the headline—but it isn't suitable for running in great quantity and it definitely looks better run large.

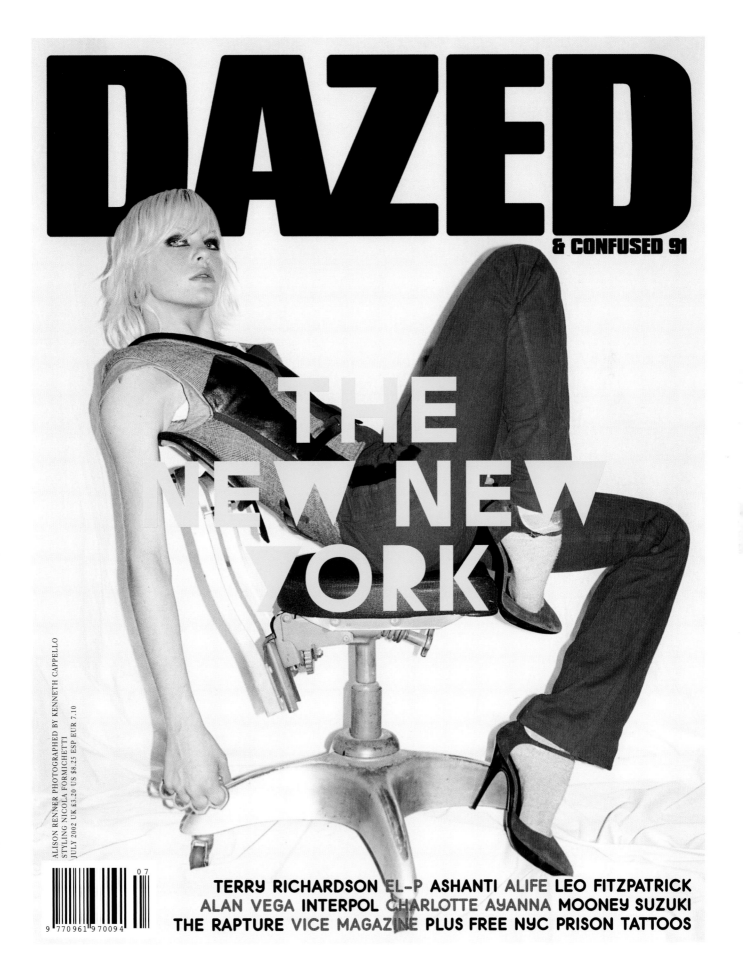

DAZED

& CONFUSED 91

THE NEW NEW YORK

ALISON RENNER PHOTOGRAPHED BY KENNETH CAPPELLO
STYLING NICOLA FORMICHETTI
JULY 2002 UK £3.20 US $8.25 ESP EUR 7.10

9 770961 970094 07

**TERRY RICHARDSON EL-P ASHANTI ALIFE LEO FITZPATRICK
ALAN VEGA INTERPOL CHARLOTTE AYANNA MOONEY SUZUKI
THE RAPTURE VICE MAGAZINE PLUS FREE NYC PRISON TATTOOS**

CHAPTER 02

FASHION
ION

Fashion graphics are as important as the clothes they are designed for. The logo and communications in which a typeface is used are vital for the marketing and image of a fashion brand. Think of iconic brands such as Christian Dior, Chanel, and Gucci whose logos are more recognizable than their clothes, and account for a large percentage of sales through branded accessories.

The same idea applies to the designs featured in this book. Fashion is one area of design that dictates a highly versatile font. Typefaces have to be flexible enough to work successfully in the many, and often varied, media involved: signage, hang tags, shop windows, advertising, clothing, letterheads, packaging, labels, Web sites—the list goes on.

The work shown in this chapter illustrates that versatility through typefaces used on store windows, as an identity on labels and hang tags, on clothing, and on the Web.

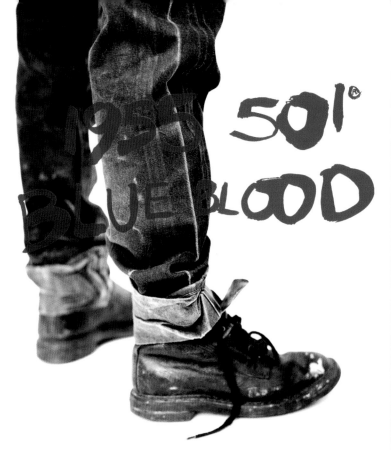

28	CHAPTER 02: FASHION	DESIGN **THE KITCHEN**

PROJECT
LEVI'S ADVERTISING CAMPAIGN

CONTACT
WWW.THEKITCHEN.CO.UK

BRIEF

Levi's has a long history of innovative advertising campaigns and memorable design, but has really upped the ante of late in the face of increased competition from other jeans brands. This typeface, for use across all media related to its vintage clothing range, is no exception. From the start, the designers decided to create a new font for the job, giving themselves the brief, "make it look like it has never seen a computer."

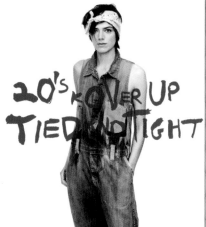

SOLUTION

Levi's Vintage is a premium, limited-edition range of clothes based on reproductions from the Levi's archives. Using a paintbrush and ink, designers at The Kitchen played around with the idea "never seen a computer," literally writing letters with a paintbrush until they were happy with each one. The letters were then scanned into the computer to make paths in Photoshop, and exported to FreeHand. In addition to their self-imposed brief, inspiration for the design also came from a 1920s photograph published in *In This Proud Land*, by Roy Emerson Stryker and Nancy Wood. The book is about the American dust bowl era and the image was of an old Model T Ford with the slogan "The Boogie Woogie" painted on its side. Named Spookie Barn, this font has a fantastic sense of freedom and of the organic, but is, perhaps not surprisingly, a little difficult to set. Spookie Barn is a headline font. For each application of the typeface, the designers had to treat the letter spacing, positioning, and size of the type in a different way to make it appear that the type had been naively daubed with a paintbrush. With no set structure for the setting of this type, every letter had to be individually placed for each set of words.

It works best really large, as shown here on shop windows. In this context it appears that it has been painted with a fat paintbrush. Used smaller it still has that bedraggled look, but doesn't have the same impact.

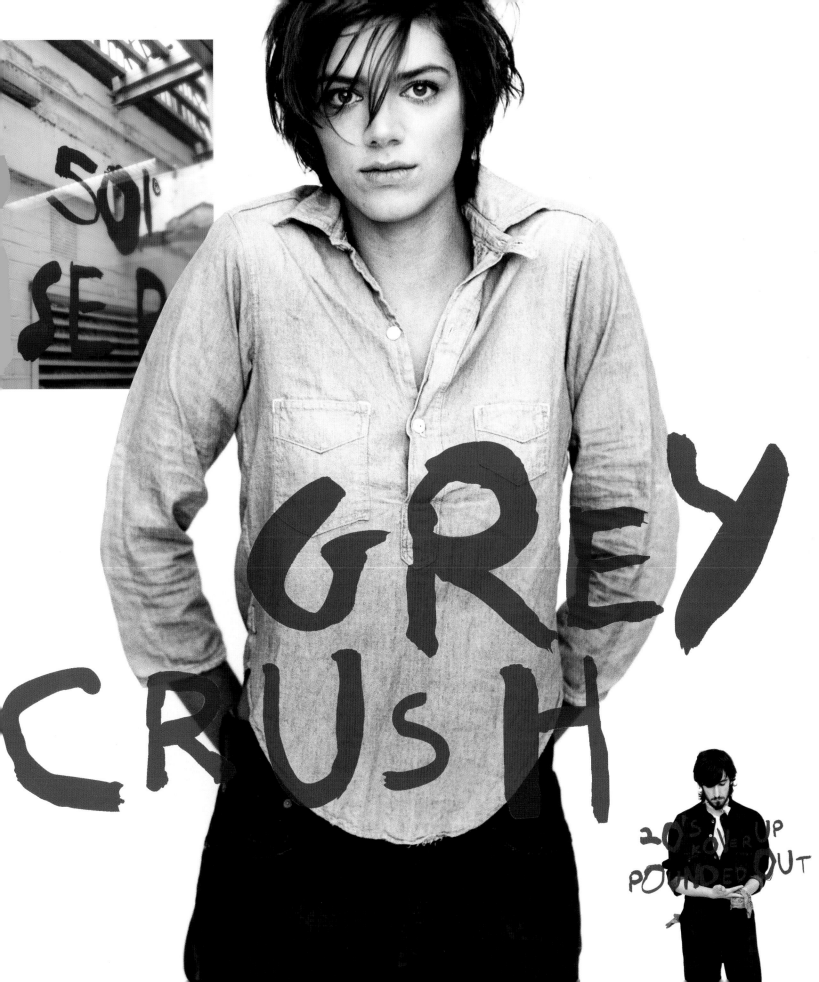

GREY CRUSH

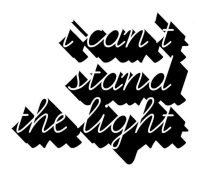

i can't stand the light

FLY or die

i can't stand the light

DESIGN
UNFOLDED

PROJECT
TOMMY FJORDSIDE PROMOTIONAL ITEMS

CONTACT
WWW.UNFOLDED.CH

BRIEF

Tommy Fjordside is an Antwerp-based fashion designer. His 2005 spring/summer collection saw the use of delicate, fragile layers of fabrics—a theme that was inspired by moths. For a number of items (shirts, postcards, CD-ROM, Web, and buttons), Fjordside needed some graphics; he commissioned Swiss designers at Unfolded to create themes and typfaces for these.

SOLUTION

Designers at Unfolded came up with two themes from the collection—Fly or Die and I Can't Stand the Light—and for each of these a typeface was created. It was important that the typefaces were adaptable because of the variety of applications for which they would be used. With Fly or Die, a scribbled letterform was adapted while for I Can't Stand the Light, a school script (one with which children learn to write) was used as the basis for the design. The typfaces were drawn on paper, then imported into Illustrator and Scriptographer before being applied to the wide range of items, including clothing. They both have a slightly retro feel to them and very much suit the style of Tommy Fjordside's clothing.

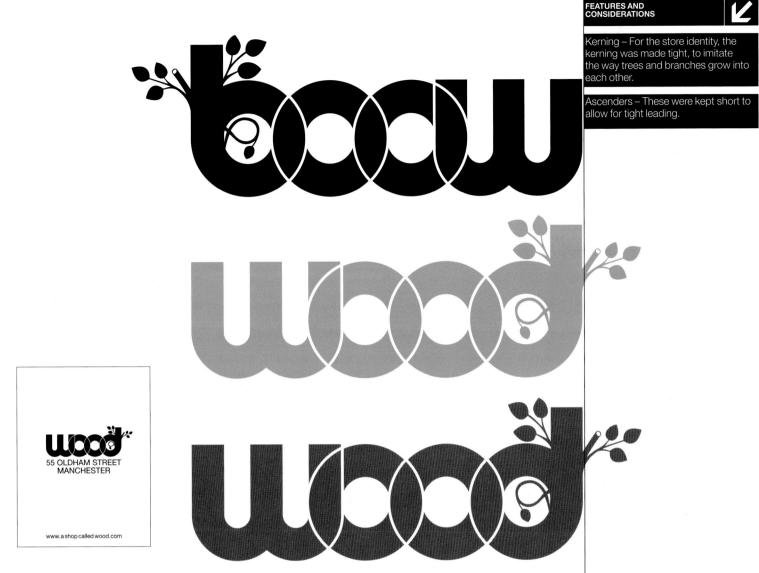

Kerning – For the store identity, the kerning was made tight, to imitate the way trees and branches grow into each other.

Ascenders – These were kept short to allow for tight leading.

55 OLDHAM STREET
MANCHESTER

www.ashopcalledwood.com

31

DESIGN
KAI & SUNNY

PROJECT
WOOD IN-STORE DESIGN AND IDENTITY

31 TYPE SPECIFIC	CHAPTER 02: FASHION	CONTACT WWW.KAIANDSUNNY.COM

BRIEF

Wood, a clothing shop, sells high-end street menswear. For its opening in summer 2004, design duo Kai & Sunny were commissioned to create an identity that would work within the clothing shop environment, and be punchy and easily recognizable.

SOLUTION

Inspired by the shop's name, the designers began looking at images of trees, woods, and forests to see how the raw nature of these things could be adapted to work within a typeface. The resulting face, Wood, is based around the idea of interlocking rings and includes elements of nature. Each letterform entwines with the next, like twisted tree trunks. This makes the word "wood" a tangle of roots, with the ascender of the final d intended to resemble a sprouting tree. The typeface was created using Photoshop and Illustrator. It has been applied to stationery, shop signage, window displays, bags, and the Web.

DESIGN
SATURDAY

PROJECT
CHEN PASCUAL IDENTITY

CONTACT
WWW.SATURDAY-LONDON.COM

BRIEF

Chen Pascual, a London-based fashion designer, has gained a strong international presence on the fashion circuit. In 2003, design group Saturday was asked to create a whole visual identity for the brand, from a company logo to swing tags and labels, visuals for fashion shows, and signage. Saturday felt that designing a custom font was necessary in order to create standout in the cluttered and competitive world of fashion.

SOLUTION

Warwick, this elegant, stencil typeface, displays a unique blend of the classical and the modern, a mix of formal and informal. The idea for such a typeface had been in typographer Paul Barnes' head for years (since school he insists), and he created it in three days. "Part of that is that you get bored of making typefaces that take six years and still you are not satisfied with them. It makes you want to design something really quickly," he explains. "I've always been inspired by the idea of the quickly made pop single; its fantastic that you can make something in a few days but it has such a long shelf life." Begun for an American ceramics manufacturer in 1996, the job was stopped halfway and Barnes never completed the face. Warwick was left unfinished and untouched until Erik Torstensson, Creative Director at Saturday, thought it would work well for the Chen Pascual identity. With a minimal budget for the project, but a desire for a unique face, it helped that Warwick was already part made, and that it is, quite simply, a classic. Barnes used traced elements of Stempel Garamond to make a stencil, which he then drew onto the computer. He determined the x-height by trying out various options until he felt happy with the result. In this face, the ascenders are taller than the capitals, as is typical in typefaces from the sixteenth century (part of the influence behind this design). The kerning has been kept loose because, if it is too tight, parts of some letters connect with adjoining letters, which reduces its readability. As it is a display face for use on a large scale, the serifs could be made quite sharp. If reproduced on a smaller scale, such fine serifs would be lost, so, for the Chen Pascual logo, a version with bolder serifs and wedges was designed. This reproduces clearly in more testing applications: on labels, reversed out, and so on.

CHENPASCUAL
ALWAYS
& FOREVER

Spring-Summer 2004

HE CAME RIDING FAST LIKE
A PHOENIX OUT OF FIRE FLAMES

HE CAME DRESSED IN BLACK
WITH A CROSS BEARING MY NAME

PJ HARVEY

@!?&

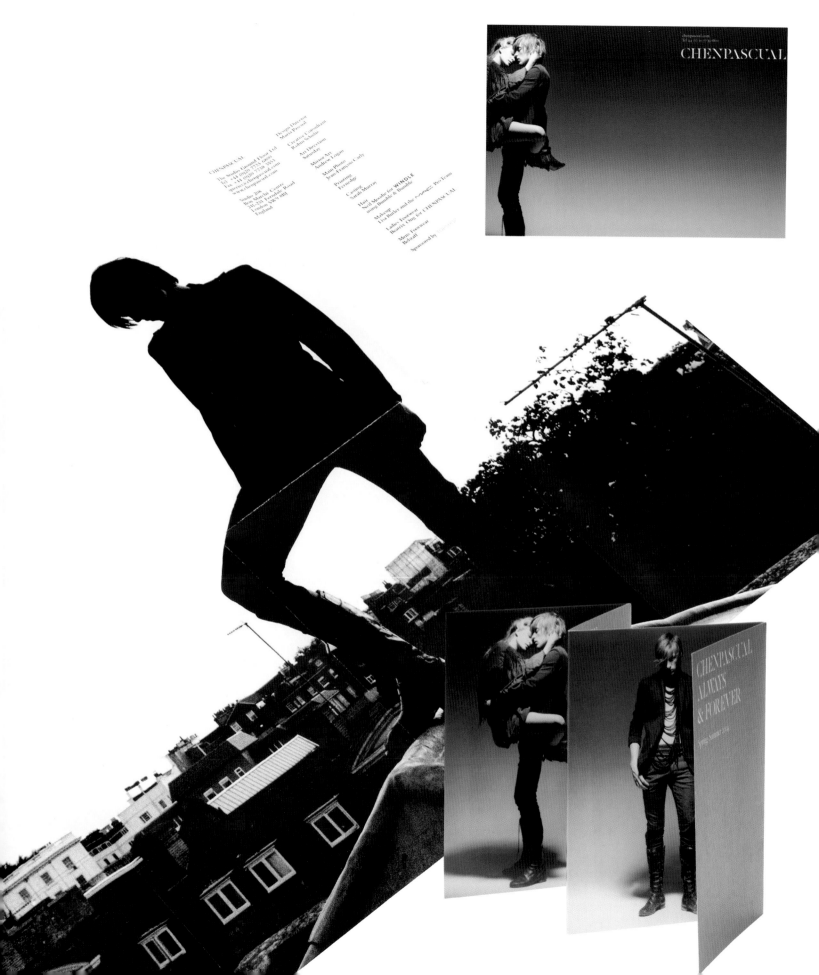

ABCDEF
abcdefg
123456
!"#$%&'(
¡¢£/§'"«

decades inc

decadesincvintagecoutureandacc
trementscameronsilver8214-1/2me
oseavenuelosangelescalifornia900
usatel323-655-0223fax323-655-017
ww.decadesinc.com

decadesincvintagecoutureandaccoutrements8214-1/2melroseavenu
elosangelescalifornia90046usatel323-655-0223fax323-655-0172ww
w.decadesinc.com

 34

DESIGN
COREY HOLMS

PROJECT
DECADES INC. IN-STORE DESIGN AND IDENTITY

CONTACT
WWW.COREYHOLMS.COM

BRIEF

Decades is a vintage couture boutique
in Los Angeles, selling pieces by
Hermès, Yves Saint Laurent, Gucci,
Pucci, Loris Azzaro, Balenciaga, and
so on. After one year of trading, the
store's owner asked designer Corey
Holms to create a new identity for the
shop, including a different typeface.

IJKLMNOPQRSTUVWXYZ
ijklmnopqrstuvwxyz
90
+,-/:;‹=›'?°-×
|†●›'...‰°¿ꟼØŒæıøœß™

decadesinc

decadesincvintagecoutureandaccoutrements,8214-1/2me
sangelescalifornia90046usa

SOLUTION

Inspired by the name of the store, Holms looked through design history books for opposing styles that would, with a little playing around, actually work together. "I was trying to find different decades of type styles that had nothing in common, but ones that I could meld together into one newish-looking style," he explains. The computer monitors in Kubrick's *2001: A Space Odyssey* were a main point of reference, as was the typography of the Vienna Secession, specifically the way such type ran together with no word spaces, occasionally breaking midword to go to the next line. This combination echoes the anachronistic nature of the store's business—selling vintage couture contemporarily.

The letters of the typeface, named Decades OS, combine both square and rounded forms and are, in a word, "skinny." "I felt, at the time, that some of the best fashion houses had really skinny typefaces in their logos, so decided that the type for Decades should almost be ridiculously skinny," explains Holms. "It had to look modern, without being tied to a particular era. Not so much timeless as not belonging in a specific time."

Signage has been a particularly difficult application for Decades as there is a city ordinance preventing the store from using a horizontal sign. This means that in addition to the type being so "skinny," it has the further restriction of having to be read vertically; although the basic letterforms are square, ascenders and descenders make it difficult to maintain consistent spacing. In order to compensate for this, Holms has used contrasting colors and made a second, bolder weight for the typeface. It works most effectively on stationery, in small point sizes. When used small, the quirkiness of the face adds character, but when it is large, this detracts from its readability as viewers focus on the individual forms rather than reading smoothly.

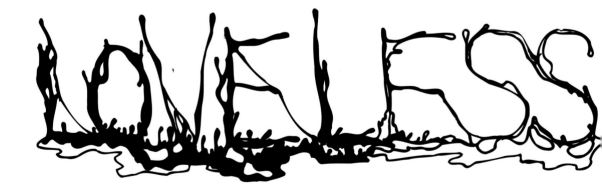

36

SURFACE2AIR, PARIS
DESIGN

LOVELESS IN-STORE DESIGN AND IDENTITY
PROJECT

36/37
TYPE SPECIFIC

CHAPTER 02:
FASHION

CONTACT
WWW.SURFACE2AIR.COM

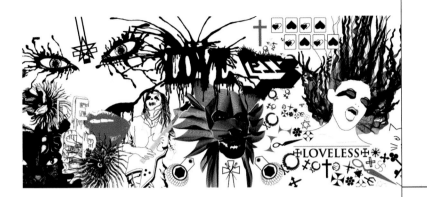

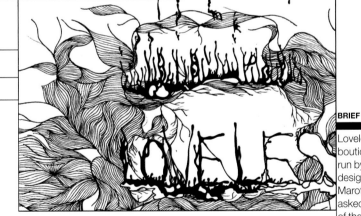

SOLUTION

The project was commissioned and completed between May and July 2004. Inspired by the ambience and language of the Loveless boutique as well as heavy metal music and the whole genre of dark vampire films, Rozan and Marotto have created a series of typefaces for the store. Each one has been applied across various media. Together, the organic, energetic fonts have a real impact. Adobe Streamline and Illustrator were used to create the fonts.

As a free and rather "chaotic exercise" for the designers, the process was closer to illustration than to traditional typeface design; it does not follow any rules or conform to any constrictions. Based loosely on Cooper, this new font has been named Love.

BRIEF

Loveless, a Japanese clothing boutique in Tokyo, is owned and run by Sanyo Shokai Ltd. French designers Jeremie Rozan and Santiago Marotto at Surface2Air, Paris, were asked to art direct the interior design of the store and to create an identity that could be applied throughout the boutique and on business cards, bags, boxes, and so on.

·LOVELESS·

YUCHI YOSHII
Creative Director

Sanyo Shokai Ltd.
1-24-3 Minami Aoyama
Minato-ku Tokyo 107-0062
Tel. 03 3401 2301
Fax. 03 3401 2301

WAYFIND
D
SIGNA

38

DING

ING

AN

AGE

Typography is central to how we communicate. It influences almost everything we do: where we eat, how we shop, what we read, where we play, and of course, how we get around. It directs us through our days, whether this be on the roads, in a museum, or at an airport. Signage, and the typefaces designed for it, are vital for keeping the world moving. Consequently, performance requirements for the characters used in signage are very different from those used in books and magazines.

On such projects, a bespoke font is a real advantage as it allows the designer much closer control of all the elements. An obvious example is Jock Kinneir's British motorway signage solution, Transport. This was first used in the mid-1950s for a signage system at Gatwick Airport, following which it was applied to signs in London and, in the mid-1960s, on all British motorways and roads. The lettering and modular layout made Kinneir's design a renowned success. It has since inspired many signage systems around the world.

In 2004, Sheffield City Council began work on a five-year urban regeneration project for this city in northern England. Together with various partners, including the city's universities, museums, galleries, theater trusts, and Passenger Transport Authority, the Council's plan included reshaping the street pattern and creating a series of new public spaces. To connect all of this, a new wayfinding solution was required. The job was given to designers at Atelier Works, and typographer Jeremy Tankard.

Sheffield has a strong history of type design and production—the Stephenson Blake foundry was established there in 1819. The design of a bespoke typeface for the wayfinding system was seen as an appropriate tribute to this typographic heritage, as well as a means of ensuring that the system was distinctive and unique. It was also felt that with the scale of the project— around 240 maps and diagrams—this would help control the initial and ongoing outputs.

The designers spent over eight months researching and developing a concept for the Sheffield wayfinding system, including maps, diagrams, photography, typography, and iconography.

Inspiration was taken from some of the Stephenson Blake types, notably the Victorian Grotesque sans serifs and Granby, designed in 1930, and from benchmark font designs such as the London Transport typeface, Johnston. Tankard worked with Atelier Works to develop the face over about three months, refining and modifying drawings on paper before developing it fully in FontLab.

Sheffield Sans, as it was named, has slightly condensed letters with clean lines and a variety of terminal endings across its forms. These help to keep the flow and image of the text alive while being economical with space, and legible on signing and in text. The diamond dot, a strong feature of the type, is included as a direct link to Stephenson Blake's Granby type and, in turn, to Sheffield. Additionally, and unusually, the sans-serif form has a ligature set, which links it to the English tradition. "We needed a slightly condensed typeface for the sign system, something that would allow us to control the consistency of the wayfinding," explains John Powner at Atelier Works. "Calling it Sheffield Sans also provided us with a basic identity that is consistent and relevant to its culture, and that to some extent projects the city's brand values such as straightforwardness, accessibility, and high quality."

The typeface was produced using OpenType technology. This format is fully compatible between Macintosh and Windows. It can also be "programmed" to have intelligence so that various applications can make use of added typographic support, such as extended ligatures. Sheffield Sans was launched in three weights to give designers choice in the broad scope of applications in which it may be used. In the ambitious wayfinding scheme, this spans vehicle signs, public transport information, and pedestrian and cycling wayfinding. Over 100 sign panels, at every level, from maps and diagrams to headline type, are in place across the city.

40 ATELIER WORKS

DESIGN

PROJECT
CITY OF SHEFFIELD SIGNAGE SYSTEM

CONTACT
WWW.ATELIERWORKS.CO.UK

Sheffield Sans

Sheffield Sans

Sheffield Sans

A X Ï i œ š ¤
B Y Ñ j æ ù €
C Z Ò k à ú £
D Þ Ó l á û $
E Ð Ô m â ü ¢
F Ł Õ n ã ý ¥
G Ø Ö o ä ÿ ff
H Œ Š p å ž 0
I Æ Ù q ç ? 1
J À Ú r è ? 2
K Á Û s é ff 3
L Â Ü t ê ? 4
M Ã Ý u ë ? 5
N Ä Ÿ v ì fi 6
O Å Ž w í ffi 7
P Ç a x î ? 8
Q È b y ï ? 9
R É c z ñ ? 0
S Ê d ß ò ? 1
T Ë e þ ó ? 2
U Ì f ð ô fl 3
V Í g ł õ ffl 4
W Î h ø ö a 5
 o

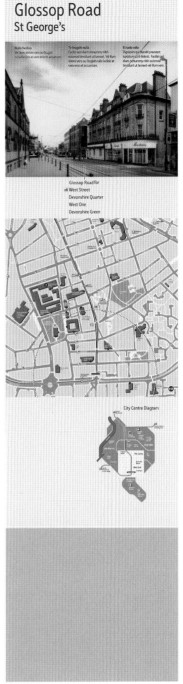

Glossop Road
St George's

Glossop Road for
West Street
Devonshire Quarter
West One
Devonshire Green

City Centre Diagram

Sheffield
Sheffield
Sheffield

42

JEREMY TANKARD

CHRISTCHURCH ART GALLERY SIGNAGE FONT

CONTACT
WWW.TYPOGRAPHY.NET

BRIEF

The Christchurch Art Gallery is one of New Zealand's best-known public art galleries. In 2003, a new building was added to the main gallery, and London-based type designer Jeremy Tankard was asked to create a font that could be used on signage throughout it. Strategy, the New Zealand–based company responsible for the design of the signs, initially asked him to create a display face in one weight, but as the brief was worked through, this was expanded to three.

SOLUTION

Strategy wanted the font to have a flowing feel, to pick up on the flowing lines of traditional Maori art. With this in mind, Tankard began looking at historical scripts and typefaces such as the Cancelleresca Bastarda type by Jan van Krimpen, which has long, ornate swashes. However, the typefaces also had to have a likeness to Tankard's Bliss, the core font used by the gallery. The basic forms of Bliss were chosen for their simplicity, legibility, and their soft, flowing curves. "I started with Bliss Extra Light, but soon moved away as the design solidified," explains Tankard. "As with other types, I started with a few test characters. I produced a test font with some of the ligatures and alternate characters. This went down well and the font developed to over 500 characters in each weight. I designed it as a Multiple Master font, which allowed me to fine-tune the middle weight on the final build."

Strategy wanted a font similar to Tankard's Blue Island, a serif face, but sans serif. Rather than producing Blue Island without serifs, Tankard explored a vertical/italic script. He wanted to move away from a calligraphic feel. Typically, such scripts have sloping ends to characters, a slightly condensed feel, and flowing lead-in and lead-out strokes. Instead he made the forms vertical and wide, and added stiff lead-in strokes. The collection of characters is balanced between roman and script; no preference is given to one or the other, and the setting appears even. The many ligatures and alternates help to keep the identity alive and interesting. The font has been made in the OpenType format, a technology that is fully compatible across platforms, and offers a huge amount of creativity to the font designer and the end user. The font has been used in many situations, including in print for literature and billboards, cast in steel for signage, and stitched onto uniforms.

JAPONISM IN FASHION

ISSEY MIYAKE YVES ST LAURENT JEAN-PAUL GAULTIER JOHN GALLIANO
THE KYOTO COSTUME INSTITUTE CHRISTIAN DIOR COMME DES GARÇONS
YVES ST LAURENT AMY BEER GIVENCHY JUN TAKAHASHI CHRISTIAN DIOR
ISSEY MIYAKE YVES ST LAURENT JOHN GALLIANO GIVENCHY
CHRISTIAN DIOR COMME DES GARÇONS DOEUILLET YVES ST LAURENT AMY LINKER
GIVENCHY JUN TAKAHASHI CHRISTIAN DIOR ISSEY MIYAKE ROUFF OF PARIS
COCO CHANEL COMME DES GARÇONS CHRISTIAN DIOR DOEUILLET
YVES ST LAURENT MADELEINE VIONNET AMY LINKER GIVENCHY
CHRISTIAN DIOR ISSEY MIYAKE RO...
THE MISSES TURNER CHRISTI...
YVES ST LAUR...
...Y M...

...JCK...
JUN TAKAHAS... ...AUR... ...LINKER BEER CHRISTIAN L...
CHRISTIAN DIOR... ...ANELIS... Y MIYAKE JOHN GIVENCHY THE KYOTO CO...
GIVENCHY JUN TAK... ...E DES... ...GÇONS DOEUILLET YVES ST LAURENT AMY LINKE...
THE MISSES TURNER Ch... ...USTIAN DIOR ISSEY MIYAKE
YVES ST LAURENT AMY LINKER... ...AN DIOR COMME DES GARÇONS
ISSEY MIYAKE MADELEINE VIONNET ROUFF OF PARIS... ...GÇONS DOEUILLET
THE MISSES TURNER CHRISTIAN DIOR COMME DES GARÇONS DOEUILLET
AMY LINKER BEER GIVENCHY JUN TAKAHASHI CHRISTIAN DIOR ISSEY MIYAKE
YVES ST LAURENT CHRISTIAN DIOR COMME DES GARÇONS DOEUILLET AMY LINKER

...JOHN GALLIANO YVES ST LAURENT
WORTH COCO CHANEL BEER GIVENCHY
JOHN GALLIANO GIVENCHY

FEATURES AND CONSIDERATIONS ↙

Character forms – a, e, f, g, k are script-based; b, d, p, q, i, l, h, m, n, r have script elements (lead-in and lead-out strokes); c, j, o, s, t, u, v, w, x, y, z would sit happily in a roman type: they have no script feel.

Welcome

TE PUNA O WAIWHETU
CHRISTCHURCH

44
DESIGN
HANSJE VAN HALEM
WITH NADJA HANKE, DROOG DESIGN, AND GO SLOW

PROJECT
GO SLOW EXHIBITION SIGNAGE AND PROMOTIONAL MATERIAL

44/45
TYPE SPECIFIC

CHAPTER 03:
WAYFINDING
AND SIGNAGE

CONTACT
WWW.HANSJE.NET

BRIEF

Droog is a group of Dutch designers perhaps best described by their own explanation on the company Web site. "Droog is a brand and a mentality. Droog is a curational collection of exclusive products, a congenial pool of designers, a distributed statement about design as cultural commentary, a medium, working with cutting-edge designers and enlightened clients." Droog asked Dutch designers Hansje van Halem and Nadja Hanke to create the signage, invitations, and brochures for a show they held at the Salone del Mobile in Milan, Italy, in 2004.

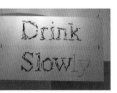

SOLUTION

Halem and Hanke created the two typefaces shown here, Stitch_unsewed and Stitch_backside. The type on the signage is actually embroidered onto a building material—a perforated white hardboard. For the brochures and invitation, the embroidery was translated into a double-sided typeface; the front showed a neat stitch while the back showed exactly what the reverse of a fabric swatch looks like when you stitch letters onto it.

"The theme of the exhibition was slowness," explains Halem, "so we thought that the fact that embroidery is a very slow, and maybe also old-fashioned or outdated method of making something, it would reflect the theme well."

For the printed typeface, the designers used the outlines of Times New Roman to work around within a grid. The grid was similar to that of the perforated hardboard, but instead of using thread as they did on the board, they "embroidered" the front of the words, using a mouse on a computer, and the back of the words, with their connected lines and letters, using Fontographer and Illustrator.

The one problem with the font is that, technically, the "stitch" doesn't fully function; letters still have to be connected by hand, as if they have been embroidered with thread. However, once set, its simplicity and the mix of craft and technology means that it really stands out as something different, especially on signage.

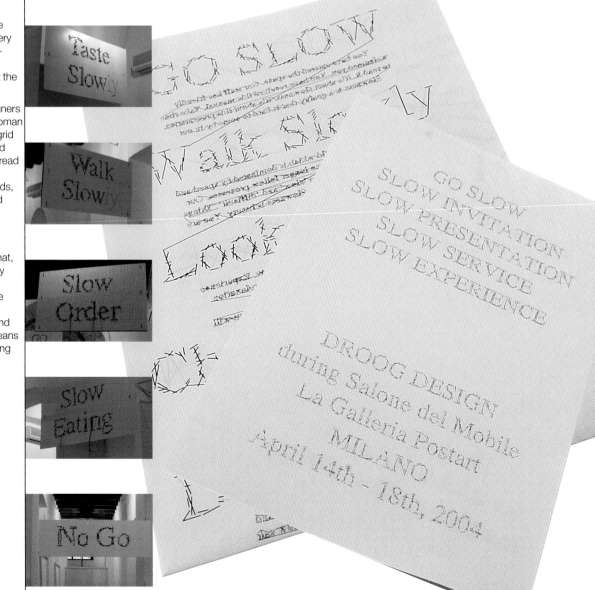

Hardwood Hammock

Biscayne
National Park

National Park Service
U.S. Department of the Interior

Pause for a minute in this hardwood hammock, or "hamaca," an Indian word meaning "a tropical jungle." These forests grow on the high ground of this exposed coral reef.

Although at first glance the plants here may look similar, they are very different. The fruit of the sapodilla tree — introduced by early pioneers — was used for chewing gum. Can you smell the skunk-like aroma of the white stopper? Touch the geiger tree's sandpaper-like leaves compared to the satinleaf's silky underside. But beware of poisonwood, a tree that can cause a severe, poison-ivy-like skin rash.

Deténgase un minuto en esta "hamaca", una palabra indígena que significa "jungla tropical". Este tipo de bosque crece en las alturas de este arrecife de coral expuesto.

A pesar de que a primera vista estas plantas parecen similares, en realidad son muy diferentes. Los frutos del árbol sapodilla — introducidos por los primeros pioneros — fueron usados como chicle. ¿Puede percibir el aroma de zorrillo de la granada cimarrona? Toque las hojas del árbol de San Bartolomé que parecen de lija y compárelas con su reverso que parece satinado. Pero tenga cuidado con el chechén, un árbol que puede causar un salpullido severo en la piel parecido a la hiedra venenosa.

No toque ninguna parte del chechén (a la izquierda) o podrá sufrir un salpullido severo. Si usted toca uno, lave la parte afectada con mucha agua y jabón.

Do not touch any part of the poisonwood tree (right) or you might get a severe skin rash. If you touch one, wash your skin thoroughly with soap and water.

Geiger tree Satinleaf tree White stopper Sapodilla tree Poisonwood tree

46

DESIGN
TERMINAL DESIGN

PROJECT
UNITED STATES NATIONAL PARK SERVICE IDENTITY

CONTACT
WWW.TERMINALDESIGN.COM

BRIEF

In 2001, the U.S. National Park Service (NPS), the government agency responsible for the administration of all U.S. parks, commissioned James Montalbano of Terminal Design to rebrand and develop a new typographic identity for the NPS that could be used in all aspects of its work. The typographic palette the NPS was using had grown out of control and was no longer effectively projecting their identity. Also on the design team was Donald Meeker, who Montalbano had worked with previously.

SOLUTION

In many ways it is ongoing, but the initial type design took about a year. The original proposal was to replace the Clarendon typeface that the NPS was using on all their road signs, and the Helvetica Bold that they were using as a primary display face in their wayside signage and in their publications with Syntax, a humanist sans-serif.

The designers also proposed that a serif face could be used as a secondary font on the road signs as well as for text applications in their publications and wayside signage. However, the NPS felt that Syntax was too much of a leap: they wanted a serif design for use on road signs. Initially, after a number of fonts were presented, Sabon was chosen as a starting point. Sabon itself is unsuitable for use on highway signage, being too delicate and contrasty, so a new, specially designed typeface was developed.

"We began playing with the Old Style forms in Sabon and Garamond as well as Plantin," explains Montalbano. "Plantin, with its sturdy character, was a better starting point than Sabon, and we designed a sturdy Old Style typeface using FontLab to produce a Multiple Master font database that included instances for weight, width, and serif style."

Field tests of the font were conducted during daylight and at night on Avery Prismatic film, a high-intensity, retroreflective material. Retroreflective materials have a very high brightness. Not only are the letters reflective, the background is as well. This causes an effect known as blooming, or halation, in which the glow of the reflected light causes the letters to fill in. NPS Roadway was designed to minimize this effect. Various permutations of the new Old Style design were compared with one another and with Clarendon. Twelve people from NPS, Pennsylvania Transportation Institute (PTI), and Avery were invited to the field tests. The group picked two designs that they felt performed better than the Clarendon.

The designers developed a new proportion of lowercase to cap height in order to make the face more legible. The cap height was kept the same, but the x-height was increased so the letterforms became slightly more condensed. The new design was tested at PTI and was found to be 11 percent more readable than the Clarendon.

The typeface is now used by NPS on U.S. park signage and in its publications. Originally called NPS Rawlinson Railway, it has been renamed NPS Roadway.

Silver Peak
Silver Peak
Silver Peak
Silver Peak
Silver Peak

Grand Canyon

Grand Canyon

Grand Canyon

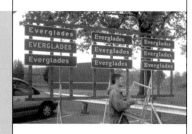

x-height – The x-height of this typeface is unusually large; it changes the traditional proportional relationship between the lowercase and uppercase letters. It is this detail that increases the font's readability and legibility.

Spacing – Spacing is a key element in signage typography. NPS Roadway uses much wider spacing than traditionally recommended, as this was also found to increase legibility.

Aa Bb Cc Dd Ee Ff Gg Hh Ii Jj Kk Ll Mm Nn
Oo Pp Qq Rr Ss Tt Uu Vv Ww Xx Yy Zz
0123456789
£$¢?€%<[["'/*-—'"@.,:!\+=+'"]]>€

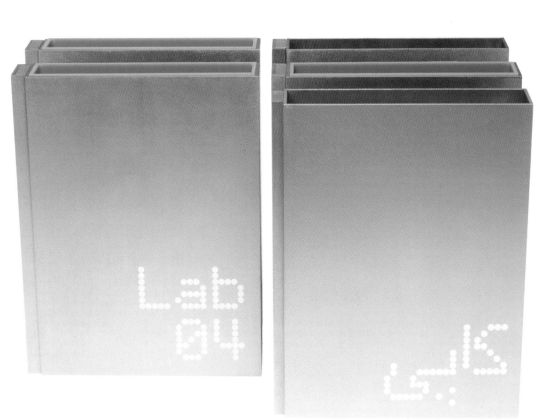

SOLUTION

Mode created a custom typeface because the dot matrix font they were working with was not going to be usable on all elements of the signage: the type had to be used on its side to fit the vertical signs that sit within the bookshelves, and it was not easily readable when set this way. After studying many dot matrix fonts the designers came across Matrix. They used this as a basis for the new font.

In order to make the font easily readable when set on its side, the dots within letters were stretched to become ovals. This works because the oval dots within each letter "bind together" better than circular dots, particularly when being read vertically. The tails of the g and y were also modified; they were lengthened to give them more definition, and to aid legibility.

This project was quite a challenge. Using a dot matrix font within a public signage system is unusual as the setting requires careful consideration to ensure that it is legible. If the face is used at too large a point size for the distance from which it will be read, the spaces between the dots will appear so large that the eye focuses on the spaces rather than joining the dots.

48 MODE

TOWER HAMLETS LIBRARY SIGNAGE

BRIEF

When two new libraries, or "ideas stores," designed by Adjaye Associates, were built in the London borough of Tower Hamlets, a large amount of signage was needed, as well as a large amount of books. Mode was commissioned by Tower Hamlets Borough Council to design the signage for both libraries. The typeface used had to be clear and functional, and had to work both in large and small scale.

ABCDEFGHIJKLM
NOPQRSTUVWXYZ
1234567890

As part of the Melbourne Fashion Festival 2002, designer Fabio Ongarato invited Patrick Remy to curate an exhibition of contemporary international fashion photography. Thirteen of the greatest names in contemporary fashion photography, both local and international, were invited to contribute. The exhibition presented fashion photography as an art show beyond the boundaries of the magazine, to illustrate the importance and power of the medium. Fabio Ongarato Design was commissioned to create the identity, brochure, and signage for the exhibition.

The graphic language created for the exhibition was based on extruding squares and cubes, a simple dot grid, and illumination. "It is a kind of reflection of the fashion image and its own dimension, moving from the printed page into an art gallery context," explains Ongarato. The placement of these cubes was defined by a strict grid, and a decision was made to base the typeface on the same grid. As a consequence the typeface, named FPN, is monospace.

It was drawn first by hand and then refined in Illustrator. It does not have kerning pairs and must stay within the base grid. The typeface is simple, bold, and strong as well as having that all important fashion element. Monospace fonts have a somewhat irregular appearance as the usually narrower I takes up as much space as the W. This forces the viewer to read each individual letter rather than whole words. As the intention of the signage was to catch and hold the viewer's attention, this works extremely well.

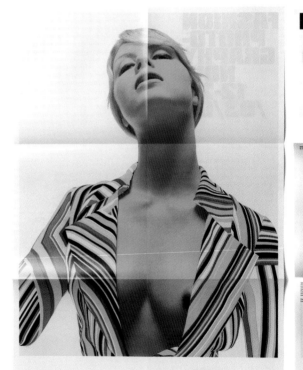

FASHION
PHOTO-
GRAPHY
NOW
12-28
/03/02

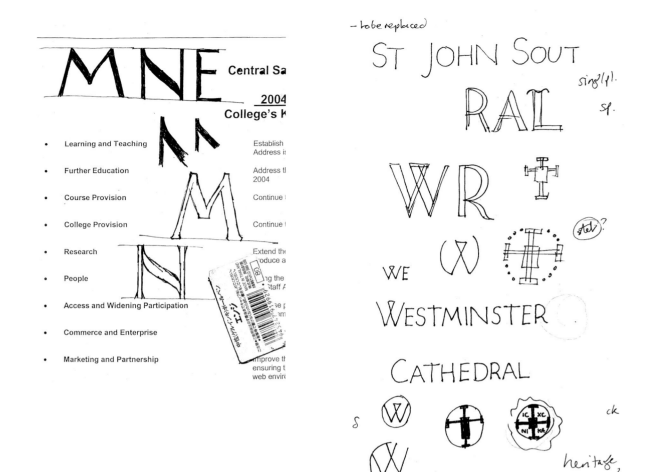

DESIGN

50 PHIL AND JACKIE BAINES

PROJECT
WESTMINSTER CATHEDRAL IDENTITY AND COMMUNICATIONS

CONTACT
WWW.PHILBAINES.CO.UK

BRIEF

In the summer of 2004, Westminster Cathedral, London, commissioned designers Phil and Jackie Baines to create a new identity for the Cathedral. The brief was to look at all aspects of its communications, from the weekly newsletter, to signage, and information provided to visitors in the building itself. The aim was to create an identity and typeface that could be used for all of those purposes.

"We wanted to produce lettering sympathetic to the building, which was a place we already knew," explains Phil. "We knew that it would need to be there for a long time, as they don't have the money to continually reinvent their identity, so it was important that it should not date."

Inspiration was not hard to find in such a building. In fact, says Phil, there was almost too much. There is an abundance of lettering and carving in the Cathedral, including Eric Gill's carved Stations of the Cross. The principal starting points for the font, however, came from lettering in the Chapel of St. Andrew and the Saints of Scotland.

As the font will probably have to work with a variety of secondary fonts in the future, the designers felt it was important that it wasn't either sans serif or serif. There are several examples of "weighted" sans serifs in the cathedral, with distinct thicks and thins, and they used these as the starting point for the new font. However, once work progressed, it became clear to them that the font needed more vigor, so vestigial serifs and tapered stems began to dominate. From the outset it was decided that the typeface should be for large uses only, and that capitals would be most appropriate. To this end, there is no lowercase version, just three-quarter sized capitals.

The new font, a work in progress at the time of writing, is named Bentley, after the Cathedral's architect. Phil is working on the font design and development while Jackie is developing the signage and exhibition graphics.

WESTMINSTER CATHEDRAL, A HUNDRED YEARS OF FAITH, PRAYER AND SOCIAL ACTION. SET IN THE NEW FONT BENTLEY.

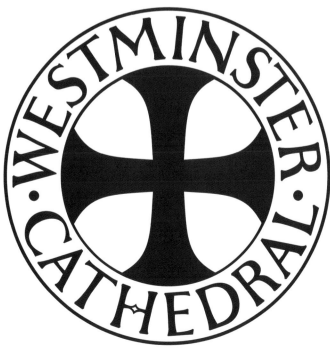

CHAPTER 04

52

IDENTITIES

Written words are essentially a substitute for spoken language. It is the job of a chosen typeface to compensate for this by communicating a message as well as expressing a tone of voice. Within identity design this "tone

This chapter is all about typefaces providing ownership and identity. If a designer is to create a new typeface, then the client must own it and it must be an integral and unique part of their brand. Type is a vital part of any communication,

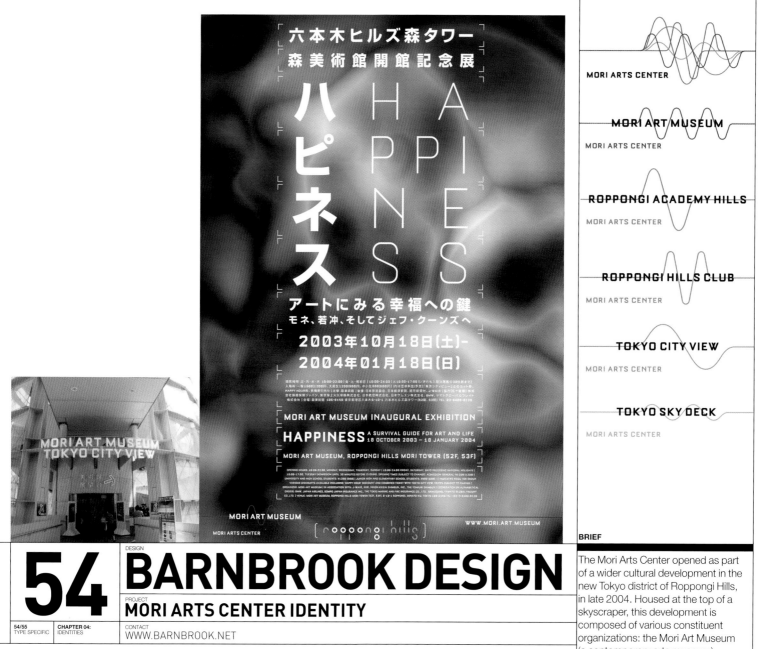

DESIGN
54 BARNBROOK DESIGN

PROJECT
MORI ARTS CENTER IDENTITY

CONTACT
WWW.BARNBROOK.NET

ABCDEFGHIJKL

MORI ARTS CENTER

STUVXYWZ

BRIEF

The Mori Arts Center opened as part of a wider cultural development in the new Tokyo district of Roppongi Hills, in late 2004. Housed at the top of a skyscraper, this development is composed of various constituent organizations: the Mori Art Museum (a contemporary arts museum), Roppongi Hills Club (restaurants and clubs), Tokyo City View (an observation deck), Tokyo Sky Deck (a conference/meeting/exhibition space), and Roppongi Academy Hills (an arts and business school).

Barnbrook Design was asked to create an identity for the center that worked for the umbrella organization as a whole, and had separate elements that could work on their own for each individual organization. In addition, the designers were asked to come up with a solution that always said "Mori Arts Center" when the separate identities were seen on their own.

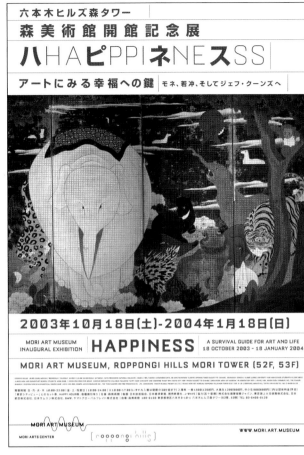

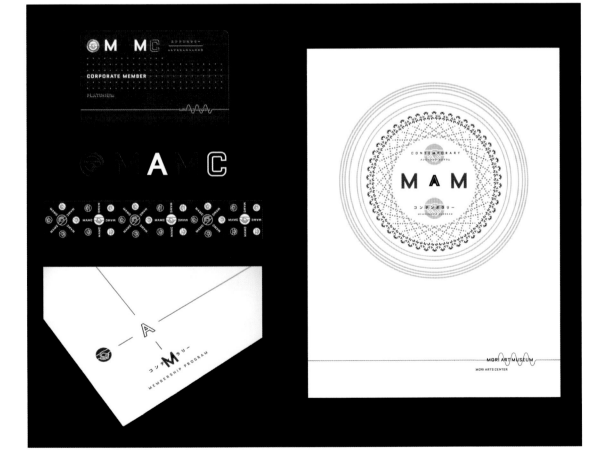

"We wanted to create an identity that symbolized activity, energy, culture, opposing views, and different art forms," explains Jonathan Barnbrook, founder of Barnbrook Design. "To do this, we came up with the idea of 'spectrum,' which could mean visual spectrum, sound spectrum, the spectrum of opposing views in art, the wide spectrum of different activities in the arts, and so on." From this starting point, each individual organization was assigned a color and a particular waveform to represent difference and provide each section with a unique branding, or identity. All the waveforms and colors combined make up the principal logo of the center. "The concept says 'we are made up of many parts which represent the whole gamut of the arts'," adds Barnbrook.

Barnbrook had worked with the company that set up the center previously—they designed its corporate identity, which included the custom serif typeface Priori. Because of this, they wanted to create a custom typeface for the Mori Arts Center that related to Priori, but they wanted a clean, bold typeface for the center's logo. To achieve this, they based the new face on the same basic character shapes as Priori, but translated the principles of Priori into a sans-serif font.

The face relates to many of the monospace sans fonts drawn in the 1970s and 1980s, which often had awkward or very basic widths due to the technical requirements for their use: as the typeface was to be used in Japan, the letters had to be extremely clear and easily identifiable by non-western readers. "It was important that the main headline font was 'cool,' but had a few 'idiosyncrasies' in it to make it a little playful," explains Barnbrook. This is reflected in the N, which is a little different from the other letters and relates directly to the original Priori N.

"When I look at these two custom fonts and how they relate to the corporation Roppongi Hills, I think that the drawing of a custom font took the whole identity to a higher level," adds Barnbrook, "It made the branding stronger and the corporate design more sympathetic to the message of the museum."

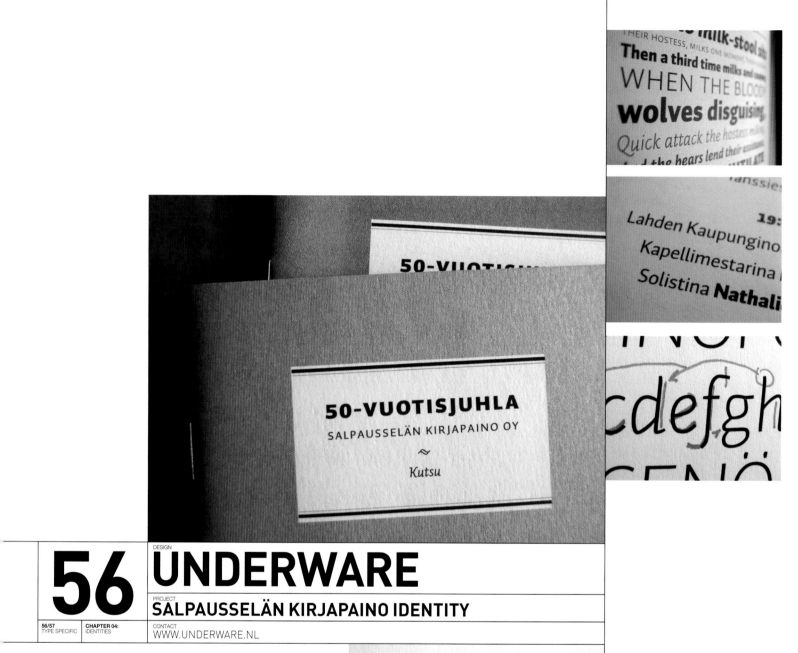

50-VUOTISJUHLA

SALPAUSSELÄN KIRJAPAINO OY

~

Kutsu

DESIGN
56 UNDERWARE

PROJECT
SALPAUSSELÄN KIRJAPAINO IDENTITY

CONTACT
WWW.UNDERWARE.NL

BRIEF

Salpausselän Kirjapaino is a Finnish printing house. To celebrate its 50th anniversary in 2002, a new identity, including a custom typeface, was created by designers at Underware. As well as celebrating their anniversary, the aim of this redesign was to improve the company's brand.

ABCDEFGHIJKLMNOPQRSTUVWXYZ
abcdefghijklmnopqrstuvwxyz&@ßfifl*¶
0123456789€$¢£ƒ¥§%‰×+†‡ªº®©™#
[\]{|}(//)<=> ,-.:;?!¿¡…··‹›«»–—"",""",,
ÄÅÀÃÂÁÆÇÐËÈÊÉÍÎÌÏŁÑÖÓÔÒÕŒØŠÜÚÛÙŸŽ
áàâäãåæçðéèêëíîìïłñóóôöõœøšúùûüÿž

STOOL REGULAR SMALL CAPS

ABCDEFGHIJKLMNOPQRSTUVWXYZ&@SSFIFL*◖◗
0123456789€$¢£ƒ¥§%‰ ×+†‡ªº®©™#
[\]{|}(//)<=> ,-.:;?!¿¡…··‹›«»–—"",""‹›,,
ÁÀÂÄÃÅÆÇÐÉÈÊËÍÎÌÏŁÑÓÓÔÖÕŒØŠÚÙÛÜŸŽ

The company's original logotype was set in Futura, which was also used in all other typographic identity. Futura is a technical, some might say cold typeface. An element of this had to be kept in the new typeface, but at the same time it had to have a little more warmth. "The goal was to make a warm, typographically rich sans serif which was not too straight or dull, but had lots of surprising details to keep it alive," explains Sami Kortemäki, designer at Underware.

The starting point for this project was an early version of Stool, which Underware had created in 2000. This was a mini family of three fonts (regular, italic, and bold) that had been used only once, and by Salpausselän Kirjapaino, for a single assignment—the publication, posters, and invitations for an exhibition at the Pori Art Museum. However, for this new identity, many more weights and styles had to be added to allow application across all the typographic material of the printing house.

Stool is a sans-serif family with a more humanistic feel than Grotesque fonts or geometric sans-serif fonts. But on the other hand, it has a more industrial feeling than humanistic sans serifs like Gill Sans, for example. The family consists of 12 fonts: roman, italic, and small caps, all in light, regular, bold, and black. The heaviness and blackness of the weights was adapted to work so that all the fonts can be combined with one another. So, the regular weight works with the black weight, the light weight works with the bold weight, and so on.

An important adjustment had to be made to the Futura J. A common letter pairing in Finnish is L and J, and this causes a problem in Futura; when these letters are paired, a large white space appears between them because they both align on the baseline. The J in Stool has been designed to extend below the baseline, which makes the typesetting, and reading, in Finnish much more fluent.

It took around five months to complete the typeface. Fontographer was used to create Mac PostScript Type 1 fonts, and FontLab was used later, to produce PC TrueType fonts. Stool has been used on printed corporate identity (letterheads), on the company Web site, and on PowerPoint presentations. It has also been adapted, in terms of spacing, for use in English.

Spacing – This was adapted especially for the Finnish language which, with its great use of double vowels and consonants, is very vertical. Compared with English, Finnish needs slightly looser spacing.

Umlauts – Adieresis (a + umlaut) and odieresis (o + umlaut) are very common in Finnish. The dots of these were designed to align with the dot of the i, to ease the flow of the reader's eye, and made slightly smaller than the dot of the i, to give visual balance.

Counterspaces – These are quite big and open to allow the typeface to be used in small sizes without a loss of clarity. When they are too small, counterspaces can fill in, depending on the type of ink and paper used for printing, and also on the point size at which the type is set. This results in reduced readability.

Contrast – The contrast between thin and thick strokes is low to allow the typeface to be used in small sizes: if thin parts are too thin, they vanish when set in very small sizes.

Hyphens – Hyphen marks are narrower than usual because Finnish has many long words that are broken up with hyphens. In narrow columns it is not unusual to have several hyphens one under the other.

58 FABIO ONGARATO DESIGN

DESIGN

PROJECT
AUSTRALIAN CENTRE FOR CONTEMPORARY ART VISUAL PACKAGE

58/59
TYPE SPECIFIC

CHAPTER 04:
IDENTITIES

CONTACT
WWW.FODESIGN.COM.AU

BRIEF

The Australian Centre for Contemporary Art (ACCA) is Melbourne's major public contemporary art space. Established in 1983, it initiates and presents innovative Australian and international contemporary art practices, and supports artists in the creation of new work. In October 2002, the ACCA moved to a new location in Melbourne's Southbank Arts Precinct. The landmark building, designed by architects Roger Wood and Randal Marsh of Wood Marsh Architecture, is very much viewed as a sophisticated space for contemporary art. Melbourne-based Fabio Ongarato Design was asked to develop a complete visual language for the ACCA— something that would capture what the center stands for and represent the spirit of the building. It also had to be suitable for use on a broad range of applications, including advertising, building signage, and printed material.

SOLUTION

The idea of the design is that it eschews a singular mark and instead, brings together a number of elements that represent the dynamics of the art displayed inside and the spirit of the building. Inspired by the post-industrial imagery of sci-fi films such as *2001: A Space Odyssey*, *Star Wars*, and *Dune*, the design is NASA-like, hi-fi rather than digital. Elements include a juxtaposition of typefaces, one futuristic and fluid and the other angular and awkward; patterns of infinite lines with no solid colors; and a color juxtaposition, green with the red building.

The designers wanted to subvert traditional notions of legibility and to this end, there is much variation between the width of individual characters. This has the effect of producing "pauses" within words, causing the viewer to reflect longer on what they are reading. To achieve this deliberate unevenness in characters, the designers examined hundreds of different words, and their unique letter combinations; in cases where some variation in the width of individual letters was required, alternatives were designed.

The ACCA typeface was drawn in Illustrator before being completed in Fontographer.

space scope

red

Text/Images/Sounds

red

a history of
happiness
nan goldin
robert mapplethorpe
barbara kruger
felix gonzalez-torres
yoko ono
jenny holzer
peter land
robert owen
aleks danko
yoshihiro suda

undertow
susan norrie

BRIEF

Minneapolis College of Art and Design (MCAD), founded in 1886, offers some of the finest art college courses and facilities in the U.S. In early 2004, Jan Jancourt at MCAD DesignWorks and Matthew Rezac at Soon After Design began work on an extensive new identity program for the college. This had not been updated since 1972. At the heart of the new identity they wanted a stable, but interesting sans-serif typeface to reflect the innovative spirit of the college. The typeface also had to be versatile, as it would be applied to signage and used within displays as well, of course, as on the extensive range of college stationery.

DESIGN
60 ANDREA TINNES
WITH JAN JANCOURT (MCAD DESIGNWORKS) AND MATTHEW REZAC (SOON AFTER DESIGN)

PROJECT
MINNEAPOLIS COLLEGE OF ART AND DESIGN IDENTITY

60/61
TYPE SPECIFIC | CHAPTER 04:
IDENTITIES | CONTACT
WWW.TYPEKUT.COM

After experimenting with many different typefaces, the pair felt that German designer Andrea Tinnes' Spectra most met the needs of the job. However, it had to be heavily customized and updated. Tinnes added two new weights and three new italic faces, recut the vertical bar, and customized letters for the MCAD logotype. The updated family was named Spektro.

The now extensive Spektro (the whole family comprises 39 fonts) consists of three different styles: Gothic, roman, and slab. To meet the need for economy with space, the basic letter shapes of Spektro are slightly condensed, and equipping it with additional weights and three different styles meets the need for it to be versatile. Spektro can be applied across a wide range of text uses. It contains the complete standard character set, supporting Western European languages, and all versions have three different numeral sets (lining figures, old-style figures, and tabular figures), to meet all typographic needs.

All versions share the same x-height (with optical adjustments for the roman version as well as the bolder weights), and the same length ascenders and descenders. They also share the same kerning pairs in all critical character combinations, including accented characters and punctuations. This allows them to be fully integrated, with no problems.

The identity solution for MCAD has a rather unusual element to it in that end users can select and manipulate images (from a library of graphic illustrations created by MCAD's students), and apply them to the item of stationery they are using. This clever quirk means that the end user is in some way involved in the design of the identity, and, each time they create a new communication, more of the MCAD identity is revealed.

"Spektro has an eclectic set of unique characters that offered a conceptual parallel to the flexibility of our identity system," explains designer Matthew Rezac. "Also, Spektro allows the end user to choose from three faces, a Gothic, roman, or slab face. These work as an integrated family, resulting in a communication that is unique to each user."

The name Spektro comes from "spectrum," the idea being that the typeface, with its three different styles, covers a wide spectrum of usage.

SPEKTRO GOTHIC

Proportions – The Gothic face is slightly condensed, which makes it very economical and efficient in terms of space. The sloped terminals of the ascenders and descenders on the lowercase characters stress this vertical nature. At the same time, the ascenders and descenders have been shortened, in order to balance this out.

Terminal strokes – The strokes of R, K, k, y are slightly curved; this gives the face a strong, rhythmic element, and makes it instantly recognizable.

"g" – The first Gothic version contained a two-story g; in the latest version, this has been replaced with a one-story g to give the face a characteristic element that differentiates it from other Gothic faces.

SPEKTRO ROMAN

Proportions – These have been slightly condensed, as for Spektro Gothic.

Contrast – There is a high contrast between thick and thin strokes to make it obviously different from Spektro Gothic and Spektro Slab.

Serifs – Reflecting Spektro's exploration of the possibilities of inconsistency and imbalance, these have been made asymmetrical.

"g" – The roman face retains a two-story g, following the tradition of serifed roman faces.

SPEKTRO ROMAN CURSIVE

Angles – The roman cursive face is a cursive/italic; it has some slightly different slope angles for optical adjustments.

SPEKTRO SLAB

Proportions – Again, these have been slightly condensed.

Contrast – There is a low contrast between thick and thin strokes (as for Spektro Gothic).

Serifs – The slab serifs have been given a triangular shape to reflect the vertical character of the face, and to distinguish it from the serifs of Spektro roman.

"g" – As with Spektro Gothic, this has a one-story g.

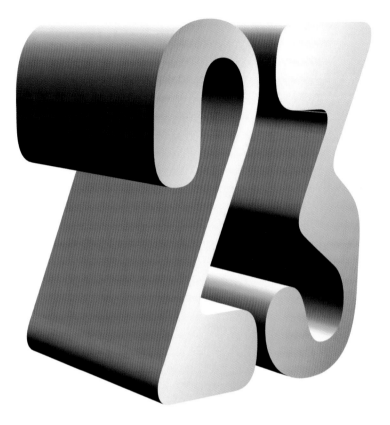

"I wanted a multidimensional, layered kind of feel to the logo to reflect the different characteristics of each floor of the club, and their individual roles in the business," explains Stewart Lucking of Craftyfish. Lucking began the project by exploring organic letterforms based around the number 23. The identity had to work with the branding of the basement club which was known as the "Two Thirty Club," a play on the club's original closing time. The typeface used for that was Amelia, a retro-looking font.

He has used a combination of warm colors, including burgundys and ochers, which reflect the interior design of the club's media/TV room, informally known as the suede room due to its suede walls and low-slung leather seats. All the colors in the logo were present in the club in some form.

The result is a logo that has a 3-D quality and appears to be a weighty piece of precious metal. It looks expensive, heavy, heavenly, and priceless. Following this, Lucking had to design a bespoke black-and-white version for use in monotone environments—faxes for example. For this he created a halftone bit-map that reinvents the logo in a pure graphic style.

62 CRAFTYFISH

DESIGN

PROJECT
23 ROMILLY STREET IDENTITY AND STATIONERY

CONTACT
WWW.CRAFTYFISH.COM

BRIEF

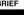
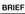

Cerberus Bars owns 23 Romilly Street, a private members' bar based at 23 Romilly St, in Soho, London, in a four-story townhouse, it has a ground-floor members' bar, second-floor restaurant, third-floor media/TV room, and a basement bar and club. It opened in 2000. The identity and subsequent graphic material for the club was designed by Craftyfish, who were given complete creative freedom. The brief was "make us funky [cool], sexy, and exclusive, and exude quality and class."

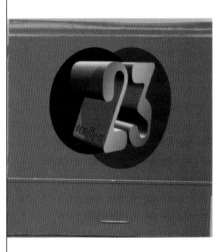

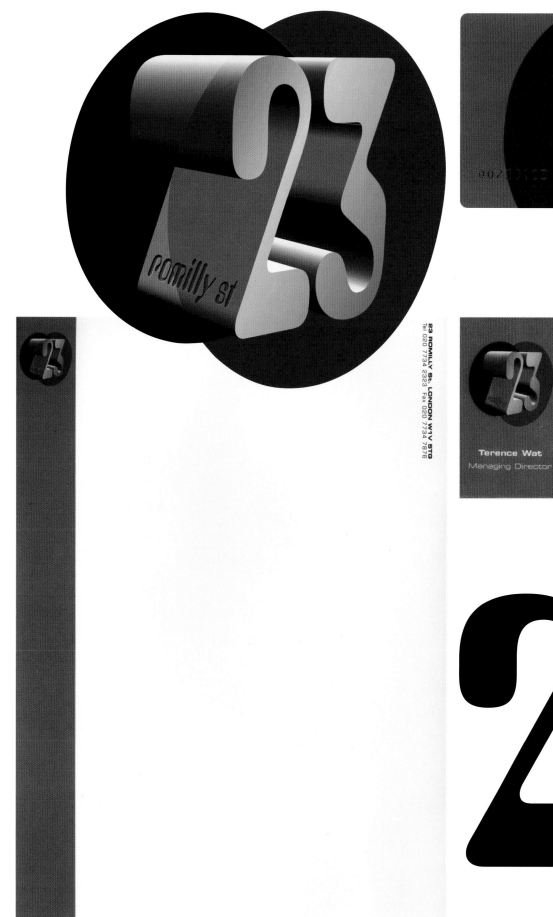

romilly st

Terence Wat
Managing Director

23 ROMILLY St. LONDON W1V 5TG
Tel 020 7734 2323 Fax 020 7734 7876

23 ROMILLY St. LONDON W1V 5TG
Tel 020 7734 2323 Fax 020 7734 7876

05 Het eigen ARBM'K' font wordt gecombineerd met een bescheiden
 (bestaand of speciaal te ontwerpen) font voor 'broodtekst'

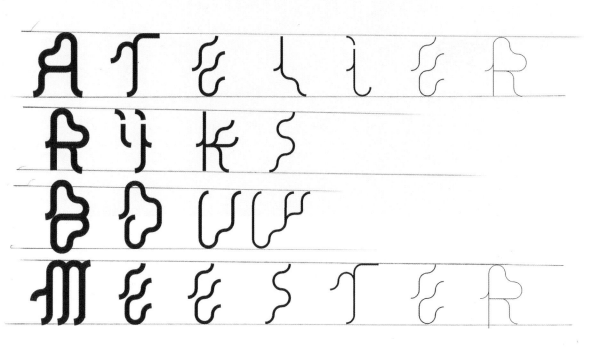

Rijksgebouwendienst
Atelier Rijksbouwmeester

Bauhaus Light

SOLUTION

The typeface, ARBM Tool Kit, was created in 2004 by Dutch designers Richard Niessen and Harmen Liemburg, then of Goldenmasters. The idea was to create an identity that was complete with instructions for how to use the face, and how it should be applied. ARBM Tool Kit was built on a square grid. Around each square are eight points to which the characters connect, some to more than others—the k connects to four, the s to only one. The idea of this connection within the design of the typeface is based on the eight "forces" which insure that the installation of the artwork goes ahead. These include the organization itself, the architect, the budget, the user, and so on. The connection and flow idea works well when the typeface is animated using Flash; you can really see the characters grow into one another. Drawn in Illustrator and imported into FontLab, the typeface has been used in all publications produced by Art for Governmental Property—books, posters, leaflets—as well as the aforementioned animations. With its many curves, organic forms, and quite extraordinary shapes, the designers certainly met the brief of creating a typeface that was distinct and instantly recognizable. Building the type on a square grid, and the whole identity on a 4 x 4cm (1½ x 1½in grid), allows it to be used successfully in both print- and Web-based media.

64 TYPOGRAPHIC MASONRY

PROJECT
ART FOR GOVERNMENT PROPERTY IDENTITY

CONTACT
WWW.TM-ONLINE.NL

BRIEF

The Dutch Art for Government Property manages all the artwork that is displayed in governmental buildings throughout the country, including prisons and courts. The organization needed an identity that could be used to communicate all the different projects that it undertakes, so it had to be a system that could be used in all media, in all sizes. It also had to be easily recognizable and distinctive.

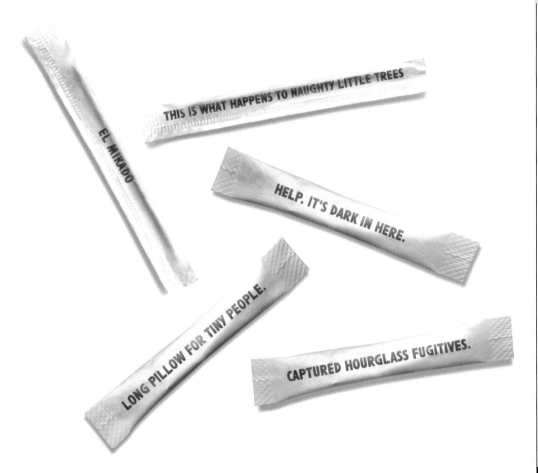

66

KARLSSONWILKER INC.

DESIGN

PROJECT
EL DINER IDENTITY

CONTACT
WWW.KARLSSONWILKER.COM

BRIEF

In 2001, Goldman Properties opened the El Diner restaurant in New York and commissioned designers at KarlssonWilker to create its identity. The restaurant is used mostly by students, and that had to be taken into consideration in creating the identity and subsequent communications.

SOLUTION

The designers were given six metal letters that the restaurant owners had found in an antique store. They began by redrawing these particular letters, then built a whole uppercase alphabet from them. The only typeface they found that resembled the metal letters was Tempo, so they used this to draw on for the remaining letters. It has been used in print, on-line, and as a headline font on products within the restaurant including sugar bags, napkins, and signage. With no set kerning or baseline, the letters "dance." Each letter is set by hand to ensure that the spacing is right.

ABCDEFGHIJKL
MNOPQRST
UVWXYZ
1234567890
$@&!?

LOVES ME, LOVES ME NOT...

THIS NAPKIN BELONGS TO:

EL DINER

CHAPTER 05

The graphic art of poster design has produced some of the most memorable, creative, and concise examples of graphic design to date. It has a long and rich history as a method of advertising and promotion, and many designers have made their name within this field.

In the mid-1800s, Jules Cheret was among the pioneers of poster art. His distinctive designs inspired many more artists, including Henri de Toulouse-Lautrec, creator of the famous Aristide Bruant dans Son Cabaret; Leonetto Cappiello with his cartoon-like images; and Czech artist Alphonse Mucha who became the star of the poster-art movement under the patronage of Sarah Bernhardt.

Many of the typefaces used on these early posters were highly decorative and often hand-drawn or painted by the poster artist. At the time, combining illustration and text to create a complete image was considered art rather than graphic design.

As a means of communication, posters have proved invaluable. The London Underground pioneered the use of posters as an advertising medium to promote places of interest and encourage people to move to newly developed, greener residential areas.

During WWI, posters were used as powerful methods of propaganda by both sides. By WWII, they were used to provide information about the war and to boost public support and morale. Today these posters are highly collectable, along with film, concert, and other classic advertising posters. It is an area of graphic design that has a strong appeal well beyond the design field.

It is also an area that gives designers real creative freedom. The poster is the perfect blank canvas. This chapter looks at what designers have made of this freedom, with a collection of posters from around the world.

PROMOTI

68

The shows were packaged together and called The Long Dark Summer—a humorous antidote to some of the rather more typically lighthearted summertime programming and advertising around at that time of year. However, it also reflects the content of the shows, each of which has become pretty notorious for exploring the somewhat darker issues in life—crime, murder, death …

The basis of the visual theme for The Long Dark Summer was Californian/Hawaiian summers, and this provided the starting point for the designers' research. They felt that a tight integration between typography and illustration was required, so it was important that a new typeface was created for this brief. Besides, no existing typeface suited the job. Typographic references were drawn from Hawaiian and surf culture, American football logos, and ice hockey.

The typeface was sketched quite freely, with technical details not really a major point of consideration, as the designers were dealing with individual words rather than a whole workable alphabet. Once the basic letterforms had been created, illustrations were applied in and around them to create the final images, which included Violence, Greed, Paranoia, and Death. The colorful, seemingly playful illustrations mix the Californian/Hawaiian summer iconography of palm trees, surfers, and waves with knives, guns, and bullets. "The typographic design and style was really in touch with our brief and concept which helped communicate an instant message to E4's audience for the ads," explains Jon Kenyon, designer at Vault49. "We were really happy with the final designs, and feel that the project shows what can be achieved when a client is open to input from their creatives at all stages of a brief, and willing to allow such a free reign to their design team. We have a lot of respect for 4creative and E4 for their approach to this brief."

The issues that needed to be addressed for the on-air use of the type were of a technical rather than a visual nature. The type was created as a vector image, point by point, to ensure that it could be edited and animated easily, without any loss of detail, when integrated with moving image.

70

VAULT49

E4 PRINT AND ON-AIR PROMOTIONAL CAMPAIGN

70/71
TYPE SPECIFIC

CHAPTER 05:
POSTERS AND
PROMOTIONS

CONTACT
WWW.VAULT49.COM

BRIEF

To support a new series of adult drama programs on U.K. satellite channel E4 during the summer of 2004, producers at 4creative commissioned New York–based designers Vault49 to create a print and on-air promotional campaign. E4 is known for showing programs such as *Friends* and *Big Brother*, but over summer 2004, new series of award-winning dramas, including *The West Wing*, *The Sopranos*, and *Six Feet Under* were to be shown, and a campaign was needed to advertise that.

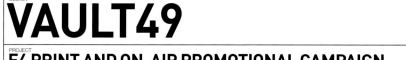

DESIGN
72 THE SMALL STAKES

PROJECT
Q AND NOT U TOUR POSTER

CONTACT
WWW.THESMALLSTAKES.COM

BRIEF

American band Q And Not U was formed by John Davis, Harris Klahr, and Christopher Richards in the summer of 1998. The band has had great success in the U.S. with a number of tours and the release of three albums. For one tour in 2003, the band commissioned designer and renowned screen printer Jason Munn, Principal Designer at California-based The Small Stakes, to create a promotional poster. He was given complete creative license.

SOLUTION

Munn has used a play on the alphabet as the basis for the poster design (omitting the "u"), taking inspiration from the somewhat unusual name of the band. The typeface itself makes reference to the old plastic stencils used in schools, with the letter shapes formed using Vag Rounded as a starting point. "Sometimes the best typeface for a specific job does not exist anywhere but in your head," Munn explains. "Having a specially designed typeface can make a more memorable and lasting piece. It usually adds a uniqueness that can't be acquired by using an existing typeface." Created in Adobe Illustrator, the actual design process was not very intensive; Munn spent more time at craft stores looking at stencils than he did drawing the face. In addition, the design did not alter much from initial sketches. As the face was going to be screen printed by hand onto posters, Munn kept detail to a minimum: perfect registration cannot be achieved with screen printing, and small details, including serifs, are often lost.
The result is a simple, organic, raw face that forms part of the process of a clever play on words. "I like that people had to discover that the letter 'u' was missing and therefore the name of the band could not be completely spelled out," adds Munn. "Although I also had people telling me that I'd forgotten the 'u'." There's always one.

While the brief did not specify a new typeface design, the idea of creating a custom typeface emerged through Fruehauf's sketching process. The idea was to create a visual language that was open and would leave room for interpretation by the viewer. It was also crucial for the typeface to connote architectural space or furniture. "I began by thinking about the environment in which product design takes place—empty spaces," explains Fruehauf. "To me these rooms represent a point of departure. I wanted to represent an abstract physical space, so I started to construct these simple geometric rooms. After a while it almost felt like they wanted to say something and they accidentally started to look like type, furniture type."

The typeface, named 15qm, evolved from these room configurations. The original room spaces were based on a square, which led to a monospace typeface. The letters are constructed from each other in quite a raw manner. Counterspaces were not constructed systematically, but rather created according to the notion of light. The result is a typeface that occupies a fine line between type and image, designed as a display font.

ABCDEFGHIJKLM
NOPQRSTUVWXYZ

ICFF
INTERNATIONAL
CONTEMPORARY
FURNITURE FAIR®

73 HELENA FRUEHAUF AT 2X4

INTERNATIONAL CONTEMPORARY FURNITURE FAIR COMMUNICATIONS STRATEGY

73
TYPE SPECIFIC

CHAPTER 05:
POSTERS AND
PROMOTIONS

CONTACT
WWW.TWOXFOUR.NET / HELLIF@AOL.COM

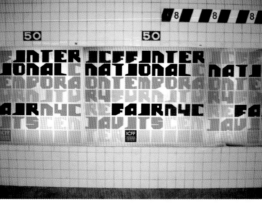

The International Contemporary Furniture Fair (ICFF), held in New York, is North America's premier event for contemporary design. The annual fair draws a varied and diverse collection of design professionals to an extraordinary display of cutting-edge furniture as well as other design events. In the summer of 2004, New York designer Helena Fruehauf, at design studio 2x4, was asked to evaluate ICFF's positioning, develop a new communications strategy, and create a visual language system for application on print and promotional materials and a new advertising campaign and Web site.

BRIEF

Tate Modern and Tate Britain, both in London, are two of the world's leading art galleries. They hold many exhibitions and art-based events each year. During 2003, designer James Goggin worked as consulting Design Director for Tate, and was commissioned to create a number of promotional posters and other material for a series of exhibitions during that time.

ABCDEFGHI
JKLMNOPQR
STUVWXYZ

Tate Sans

ABCDEFGHI
JKLMNOPQR
STUVWXYZ

Tate Regular
(designed by Miles Newlyn at Wolff Olins)

ABCDEFG
HIJKLMNOPQ
RSTUVWXYZ
abcdefghij
klmnopq
rstuvwxyz
0123456789

Tate Mono

74 PRACTISE

DESIGN

PROJECT
TATE MODERN AND TATE BRITAIN PROMOTIONAL MATERIAL

74/75
TYPE SPECIFIC

CHAPTER 05:
POSTERS AND
PROMOTIONS

CONTACT
WWW.PRACTISE.CO.UK

47% OF PEOPLE
BELIEVE THE IDEA OF
WEATHER IN OUR
SOCIETY IS BASED
ON CULTURE

53% BELIEVE IT IS
BASED ON NATURE

The Unilever Series:
OLAFUR ELIASSON

16 October 2003 – 21 March 2004

Free Admission
Open Daily 10.00 – 18.00
Late nights Friday and Saturday until 22.00

Visit www.tate.org.uk
⊖ Southwark/Blackfriars

The Unilever Series:
an annual art commission sponsored by

Unilever

MODERN
TATE

ABCDEFGHI
JKLMNOPQR
STUVWXYZ
0123456789

Tate Dot

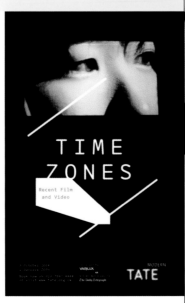

TIME
ZONES

Recent Film
and Video

MODERN
TATE

"As I started work with Tate, there was discussion of perhaps starting to deviate from the original Tate identity and its official Tate font," explains Goggin. "We thought about perhaps introducing other typefaces to use on the galleries' publicity material and exhibition posters."

Rather than go completely against this already recognizable identity, Goggin decided to customize the official font and change elements on selected exhibition projects subtly. All of his custom versions use the original Tate font as a base, so as not to contravene the identity guidelines, but make oblique references to either the artists in question, their work, or the overall function of the typeface in a gallery situation. He created four typefaces: Tate Stencil, Tate Dot, Tate Mono, and Tate Sans.

The Tate modifications made by Goggin and his team rely heavily on the foundations laid by Miles Newlyn for the original Tate font family. Most of the customized versions involved the subtraction of elements from the original. The most intense work was on Tate Mono, where equal-width slab serifs were added to characters like the lowercase i, l, and r, and the overall letterspacing of the font was changed to create equal widths, for a true typewriter mono.

The typefaces have been used in exhibition books and catalogs, on posters (both traditional double crown and larger underground and public transport campaigns), exterior exhibition banners, interior wall signage (laser-cut vinyl), and on actual artwork captioning.

Tate Stencil
Created for a Wolfgang Tillmans exhibition, If One Thing Matters, Everything Matters, at Tate Britain. "I approached the Tillmans exhibition with the idea to create a makeshift and modular version of the Tate face, but one that also retained an elegance and subtlety in letterform, mirroring both the beauty of Tillmans' photography, and his wall-hanging method, which is made just before exhibition openings, using such humble and temporary materials as Magic Tape, packing tape, and bulldog clips," explains Goggin.

Tate Dot
Designed with Laurenz Brunner for Olafur Eliasson's The Weather Project, at Tate Modern. "For Olafur Eliasson, the idea of publicizing what could be seen as an intangible artwork was tricky. Both Eliasson and the Tate were wary of people coming to see the piece with preconceived ideas and were more interested in using just the title itself to encourage contemplation of what the word 'weather' constitutes," explains Goggin. "No images of the work were to be used, in order to retain an element of surprise before the project opened." The customized font, made of "precipitation" dots over a blank space bathed in yellow, reduces Eliasson's artwork to its fundamental components of mist and light.

Tate Mono
Designed with Laurenz Brunner and used for the Turner Prize 2003, at Tate Britain, a Luc Tuymans exhibition at Tate Modern in 2004, in the Level 2 Gallery at Tate Modern, and for *Time Zones*, a film shown at Tate Modern. "Laurenz Brunner and myself made this monospace, typewriter-like version to answer our own wish for a more straightforward, utilitarian, and 'informational' cut of the Tate font, for typesetting basic information like exhibition dates, work labels in the gallery, and just to extend the overall Tate family we were starting to build upon," explains Goggin.

Tate Sans
Used for the Donald Judd exhibition at Tate Modern. "The sans-serif version of the Tate font is a tongue-in-cheek reference to the stark geometric nature of Donald Judd's work: squaring off Tate Regular's rounded corners actually ended up yielding a fairly refined sans reminiscent of Gill or Frutiger," explains Goggin.

DESIGN
76 RAFAEL KOCH

PROJECT
THE SCHOOL OF ART AND DESIGN, ZURICH
PROMOTIONAL POSTER

CONTACT
WWW.VECTORAMA.ORG / WWW.CHIDO.CH / WWW.ENCYCLOPAEDIZER.NET

BRIEF

Rafael Koch was commissioned to design two promotional posters for The School of Art and Design in Zurich, one of which is shown here. The brief was simple—convey the text he was given on a poster. Other than that it was completely open and left for him to interpret as he wished.

1.

2.

SOLUTION

The font, named Herr Stockmann, sprang from Koch's personal interest in the functionality and shapes of the old children's building toys made by Meccano and Stokys. Koch used the horizontal and vertical elements of these for designing and setting the alphabet, but after experimentation with the already existing Meccano and Stokys parts, he extended the formal repertoire of pieces, designing new shapes to use within his letterforms, as using the "found" shapes only was too restrictive. Koch followed sketches on paper, and used FreeHand and Fontographer to produce the Herr Stockmann font. Certain letterpairs—among them D and I, S and T, and C and A—proved difficult; Koch had to respace the letters, setting them individually each time they occurred.

At present, this font only exists as a series of uppercase letters. However, it is Koch's aim to extend the idea of this "formal language" of Meccano and Stokys with a full font family.

STUDIEN
BEREICH
NEUE
MEDIEN
WWW.SNM
HGKZ.CH

MECCANO
STORYS

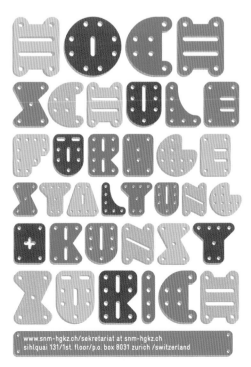

HOCH
SCHULE
FÜR GE
STALTUNG
+ KUNST
ZÜRICH

www.snm-hgkz.ch/sekretariat at snm-hgkz.ch
sihlquai 131/1st. floor/p.o. box 8031 zurich /switzerland

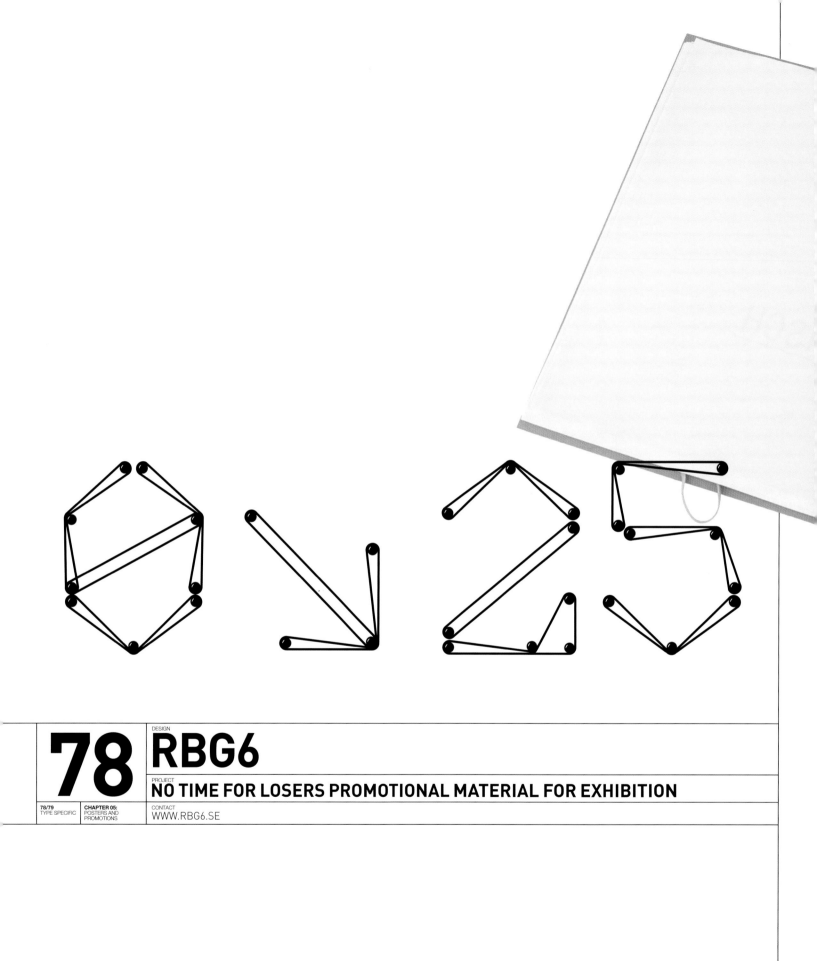

78

DESIGN
RBG6

PROJECT
NO TIME FOR LOSERS PROMOTIONAL MATERIAL FOR EXHIBITION

78/79
TYPE SPECIFIC

CHAPTER 05:
POSTERS AND
PROMOTIONS

CONTACT
WWW.RBG6.SE

NO TIME FOR
LOSERS

ÆEFGHIJLMNØRSTP

No Time For Losers is a group of curators based in Stockholm, Sweden. For an exhibition that it organized in 2004, a poster, catalog, and other printed material were required, and designers Joel Nordström and Lars Ohlin at RBG6 were given the job.

SOLUTION

The solution is a typeface created by using drawing pins and rubber bands to make the lettershapes. "I had been playing around with these materials before this project came up, and when it did, I simply adapted the idea to this project," explains Nordström.

The font, named Rubber band/Pushpin, was inspired by the pins on a message board in the RBG6 studio. The look and feel is pretty much shaped by how much one can stretch a rubber band and the other physical limitations within the materials used. Even when it was digitized these restrictions were taken into consideration.

To quote Hans Eduard Meier in *Die Schriftentwicklung* (Graphis Press Zurich, Switzerland, 1959), "The tools and the material used in writing are major determinants of its form—letters chiseled into stone and those that are written with a pen on paper will develop different forms due to these different techniques." In the first instance, each letter of this font was created using actual rubber bands and drawing pins; the letters were then photographed and digitized using Illustrator.

Rubber band/Pushpin is an all cap font: smaller letters tend to have tighter curves and smaller shapes which are hard to create, particularly as recognizable letters, using rubber bands and pins.

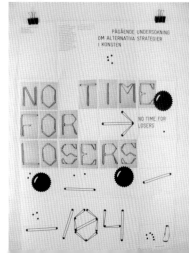

SOLUTION

The designers created a typeface, Timber Type, especially for the Beauty and The Beast identity. Timber Type, inspired by the dominance of nature in the Swedish way of life, was created by taking simple shapes and "hacking" into them as though they were wood being chopped. Shapes were then developed from Timber Type to create mysterious vessels and apertures that work as motifs across related printed matter. In effect, Timber Type has ended up providing both the type and the image for this project.

"The type was formed as if we were cutting logs," explains designer Amelia Noble. "Pieces were hacked off blocks, slotted into gaps, and piled on top of each other to form the lettershapes. We aimed to create a titling font that reflected the quirky nature of the objects the audience would encounter in the exhibition. We also wanted to make something that related to a Swedish perspective. While creating intrigue and mystery, it also needed to be bold and eye-catching and legible."

The typeface was sketched in FreeHand and then imported into Quark XPress, to be overlaid on photographic and drawn imagery. Finally, the typeface became the lettering *and* the imagery. The letterforms were completed in Illustrator, then composed in Illustrator and Quark. Timber Type has been used on promotional posters, banners, invitations, stickers, the exhibition guide, leaflets, introductory and themed exhibition panels, touring posters, and press advertisements.

80 KERR|NOBLE

DESIGN

PROJECT
BEAUTY AND THE BEAST EXHIBITION PUBLICITY MATERIAL

CONTACT
WWW.KERRNOBLE.COM

BRIEF

The Crafts Council is an organization that supports craftspeople through its gallery and shop, and through hosting exhibitions, like the Jerwood Furniture Prize. In 2004, the Council commissioned designers Kerr|Noble to design the marketing and publicity material, and the exhibition graphics for Beauty and the Beast: New Swedish Design. Designers at Kerr|Noble also worked together with the exhibition curator Lesley Jackson and the exhibition designers Stickland Coombe. The design had to work consistently across all media to give the exhibition a cohesive feel.

PETER ANDERSSON

LENA BERGSTRÖM

SARA BERNER

THOMAS BERNSTRAND

CLAESSON KOIVISTO RUNE

BJÖRN DAHLSTRÖM

MONICA FÖRSTER FRONT

MIA E. GÖRANSSON

ANGELICA GUSTAFSSON

MATTI KLENELL

ANNA KRAITZ

JONAS LINDVALL

ANDERS LJUNGBERG

ANNA KRISTINA LUNDBERG

MÅRTEN MEDBO

GUSTAF NORDENSKIÖLD

INGEGERD RÅMAN

KJELL RTLANDER

GUNNEL SAHLIN SALDO

PER SUNDBERG

PIA TÖRNELL UGLYCUTE

ANNA VON SCHEWEN

Counters – There is a lack of counters in letters such as B, A, O, P, which gives it a bold and mysterious quality.

Protruding letters – The designers wanted some of the letters—E, T, and S—to protrude beyond the boundaries of the cap line, to reveal their imperfections and simplistic form. These letters usually sit tightly on the x-height and would certainly never venture beyond the cap line.

Construction – This typeface does not exist in a format where it can be typed out via the keyboard; words are constructed as illustrations and the letter spacing is adjusted once the basic composition is set up.

BEAUTY
AND
THE
BEAST

CHAPTER 06

MU

MUSIC

JSI

C

Arguably, the packaging of a
single or album is as important
as the music on the disc or record
inside it. Most of us, whether we
admit it or not, make decisions
about purchases that are heavily
influenced by the "look" of the
product—by its packaging.
The following pages show
typefaces that have been designed
specifically for use on packaging.

The style of typeface varies
enormously when it comes to
CD packaging. The choice and use
of typeface on CD covers is quite
flexible, allowing for the use of
more unusual or experimental
letterforms. Legibility, although of
course important, is not as much
of a consideration as standout.
Many CD covers use cool, bold
typefaces that would never work
on a shampoo bottle or drinks can.

Whatever the style of music on
a CD, it is vital that the typefaces
used on its packaging "talk" to the
consumer, or potential purchaser,
and give the artist and the music
the right "voice." This must appeal
to its target market, but at the same
time the typeface itself must be
relevant to the product inside.

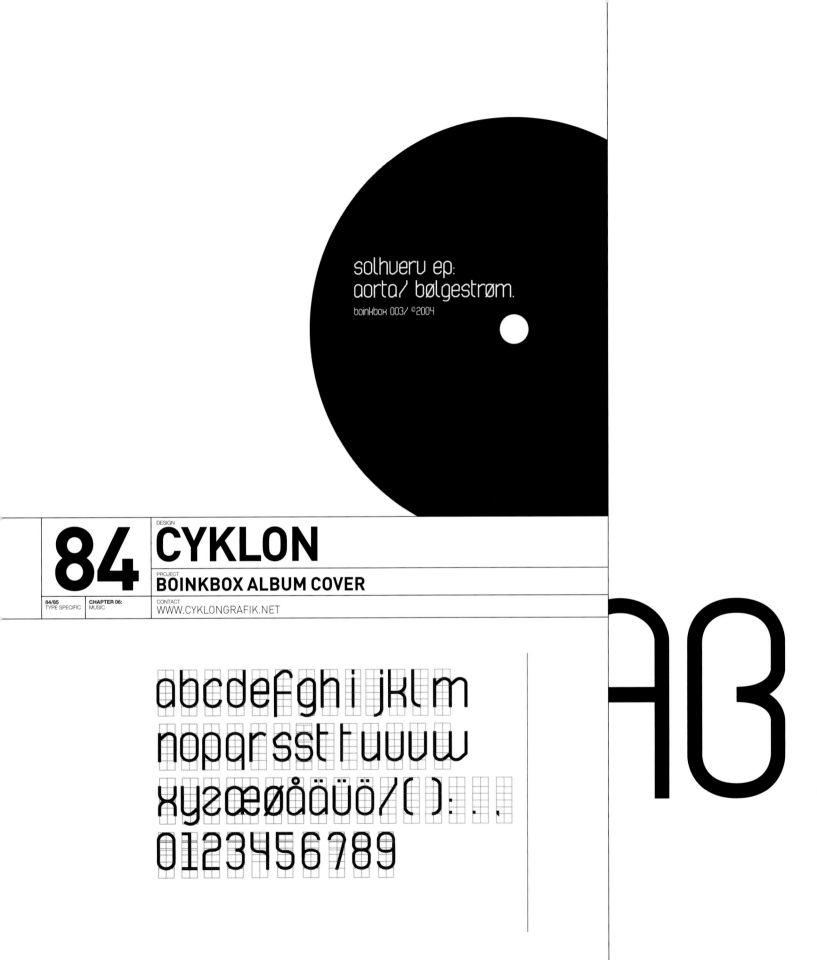

solhverv ep:
aorta/ bølgestrøm.
boinkbox 003/ ©2004

DESIGN
84 CYKLON
PROJECT
BOINKBOX ALBUM COVER

84/85 CHAPTER 06: CONTACT
TYPE SPECIFIC MUSIC WWW.CYKLONGRAFIK.NET

abcdefghi jklm
nopqrsst t uuuw
xyzœøåäüö/():...
0123456789

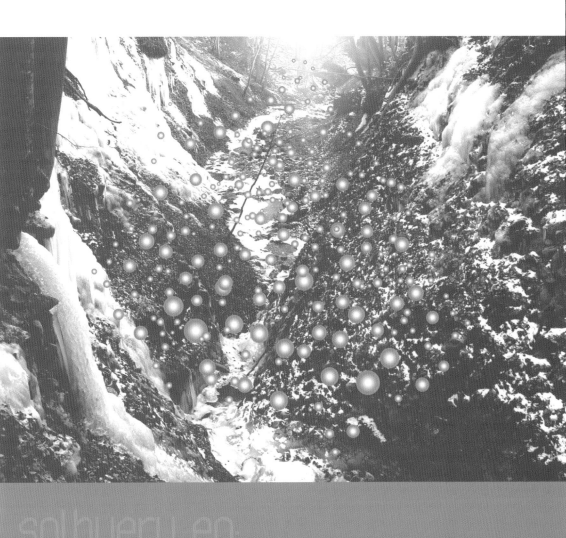

solhverv ep.
aorta/ bølgestrøm.

BOINKBOX

ABCDEEFGHIJKLMNOPQRRSSTUUWXYZ
abcdeefghijklmnopqrssttuuuwxyz
1234456789OÄÅÆÖØŒÜßåäåœöøü££¥$
(ɑ?!&¶*"'[©®™]...;\|/-☐¡¿){=+-÷<>~%‰˚}

BRIEF

BoinkBox is an independent
indietronica label, based in
Copenhagen. Danish design house
Cyklon was commissioned to create
a cover, and custom typeface, for the
vinyl EP release of one of its artists in
late 2003. The title was *Solhverv*, an
old Nordic word that describes both
the shortest and the longest days in
the year. To this end, the design of the
record cover had to, in some way, give
the impression of the darkness of
winter and the increasing daylight that
follows in the summer.

SOLUTION

Designer Henrik Gytz wanted to use
a clean, yet distinctive typeface that
would work well with the frosty
landscape image on the cover of the
album and as he could not find an
appropriate typeface in his collection,
a new one was required. The face he
designed was named C-Aorta; C for
Cyklon, and Aorta after one of the
tracks on the album.

Gytz began by drawing different
versions of the o before moving on
to the a and then the s. These three
letters provided the guidelines for the
creation of the rest of the alphabet.
A distinctive feature of the typeface is
the diagonally flattened, top left-hand
edge of many letters, and the short
ascenders and descenders. These
features help to give it the simple,
clean, tight look he was after. Gytz
developed some letterforms both with
and without flattened edges so that
they can be alternated, to add a
distinctive character to the typeface.

Sketches of the entire alphabet were
done in Illustrator and the final typeface
was generated in Fontographer.

86

HORT

PROJECT
FRANKFURT/FFM LOUNGE CD COVER
AND PACKAGING

CONTACT
WWW.HORT.ORG.UK

BRIEF

In 2004, German company Bestboy Music commissioned Frankfurt-based designers HORT to create the cover and packaging for the first in an intended series of bar-sponsored compilation CDs. The album title, *Frankfurt/FFM Lounge*, pretty much explains the concept—a compilation CD of lounge music from Frankfurt. Bestboy Music intended to adapt this compilation concept both to different music genres and to different German cities. Consequently, the cover design for this initial release had to be easily adapted for use on future CDs.

A strong visual appearance was of the utmost importance, and therefore, a strong image that would bring recognition to the brand was more important than a highly legible typeface.

SOLUTION

Looking at the brief, the solution clearly had to contain some kind of visual system. It had to show the consistency of the series, as well as the diversity of the products. The basic visual elements that the designers had to work with were the album title, the track listings, and an image of the bar or club that sponsored the compilation. Because the photographic material would change with each compilation, HORT designed a strong and unusual typeface as a means of creating consistency throughout the series. This compilation was sponsored by Frankfurt bar Sansibar, and elements of its interior decoration have been used within the title typeface.

The face is inspired by the designs of Wim Crouwel that are based on, and in some cases even made out of, grids. "We wanted to make a grid that could, on the one hand, contain the body text, and on the other, be the basis for the main album title typeface," explains designer Martin Lorenz, who created the typeface in one evening.

"The basic unit of the grid is the basic unit for the typeface. Applied to print material and Web it works well on both, but the print with special colors is of course more spectacular."

Because the typeface was designed for use on this series of albums alone, and only by Lorenz, he could leave the way the face works when laid out relatively open. There are no "rules" as such, and this allows great diversity between the products, without the series losing coherence.

Herbie Hancock is a legendary American jazz composer and musician. For the release of his album *Future 2 Future* in 2000, Keith Tamashiro of Los Angeles–based Soap Design was commissioned to design a CD package for the artist. The brief was fairly open and no custom typeface was requested by the client.

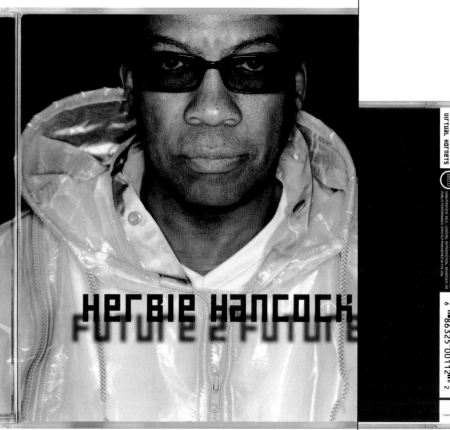

SOLUTION

"I wanted to get a futuristic feel for the Herbie Hancock album package," explains Tamashiro. "A custom typeface was not demanded, but it was something that I felt the project needed." The design of the typeface, named Hancock, came from the idea of having a modular face that was based on parts drawn from a grid. Initial sketches were made on graph paper, using the square grid to create the face before drawing it in Illustrator, then importing it into Fontographer. There is a real economy and simplicity to the font, a result of it being unicase and monospace, and it works particularly well as a display font. "It's rare that I find myself looking outside of existing typefaces for a particular project," explains Tamashiro, "but on the occasions that I've done so, it's usually because I've found something close to, but not exactly what I'm looking for. It helps when you can build certain characteristics into the custom typeface that you know will be useful based on the demands of the project."

Initially, there was the possibility that the font would be used in low-resolution formats, including Web and video, and it was designed with this in mind—the letterforms were built around a grid that would hold up well in pixel-based formats.

88
DESIGN
SOAP DESIGN CO.
PROJECT
FUTURE 2 FUTURE CD PACKAGE

CONTACT
WWW.SOAPDESIGN.COM

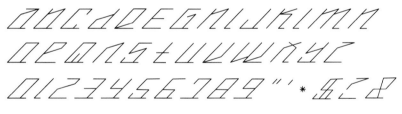

Starting with the album name, *More Than Motion*, Clark created a series of letters in Illustrator, using the pen tool. "I wanted to make something that had a futuristic feel," he explains, "but something that maybe would've been perceived as futuristic in the 1980s more than what we might call futuristic today. I think the idea of neon sign lettering was the biggest inspiration for the typeface. The album title suggested motion too, so that was another factor."

Once Clark had the basic shape for one letter—an oblong derived from a rectangle—he used that almost as a template for the rest. His first letter, M, set the angle at which all the cross sections would lie. Because it is a unicase font, there are no descenders reaching below the baseline, and Clark kept all the ascenders the same height in order to keep the shape uniform and, in turn, keep the entire set of characters within the constrains of the box shape he had created.

Most of the letters are joined; at times this reduces legibility, but what matters in this context is that the type has a real sense of flow and of motion. With so little text, and no time restrictions on the reader, the problem with legibility offers no real constraint, but rather, draws the reader in. The typeface was created in a few hours directly in Illustrator—no preliminary sketches were done.

89

ASTERIK STUDIO

PROJECT
MORE THAN MOTION CD COVER

CONTACT
WWW.ASTERIKSTUDIO.COM

BRIEF

Designers at Asterik Studio, Seattle, were asked to create the cover and packaging for this third album from Element 101, a band from New Jersey, U.S., in summer 2002. Titled *More Than Motion*, the album was released by Tooth & Nail Records. A custom typeface was not specifically requested, but designer Ryan Clark decided to create one anyway.

In 1998 Fred Deakin and Nick Franglen, aka Lemon Jelly, released the first three limited-edition 10in EPs on their own label, Impotent Fury. The records instantly became collectors' items, not only because of the unmistakable Lemon Jelly sound, but also because of their unusual packaging. The band, now signed to XL Recordings, has played a sell-out U.K. tour and been nominated for a Brit Award (annual British pop music awards), while its *Lost Horizons* album was shortlisted for the Mercury Music Prize (annual prize for best British album of the year) in 2003. Fred Deakin is also a Director at design company Airside. Along with his design team, he has created all the graphic material for the band's releases, including a custom typeface. The band makes music, but just as importantly it produces graphic images in print and motion specifically to accompany that music.

SOLUTION

Because the typeface had to define the band's identity, the band's music and name were the starting point for the design. Research and experimentation with different individual letterforms were very much part of the process, and inspiration came from 1970s' fonts such as Hot Wheels. Legibility is usually a high priority when designing a typeface, but in this case it was more important that it be evocative, and that it merged into one piece rather than sit as individual letters. This certainly comes across in the way the type interlocks in a fluid way; each letter nudges up against the next, creating the intended ebb and flow. Because the typeface was not created as a traditional set alphabet of letters, each word has to be handset, and the shape of individual letters adjusted where necessary to accommodate this "merging" of letters. Created entirely in Illustrator, each letter has been hand-drawn and is applied differently depending on context—Web site, album covers, and merchandise. The font is unique and highly appropriate for the band and its music. This designer–client union has produced some great work, and not only with this fitting typeface; the die-cut covers and use of illustration and imagery make for a great, all-round Lemon Jelly package.

DESIGN
90 AIRSIDE

PROJECT
LEMON JELLY EP COVERS

90/91
TYPE SPECIFIC

CHAPTER 06:
MUSIC

CONTACT
WWW.AIRSIDE.CO.UK / WWW.AIRSIDESHOP.COM

adeghilmnoprstuwy

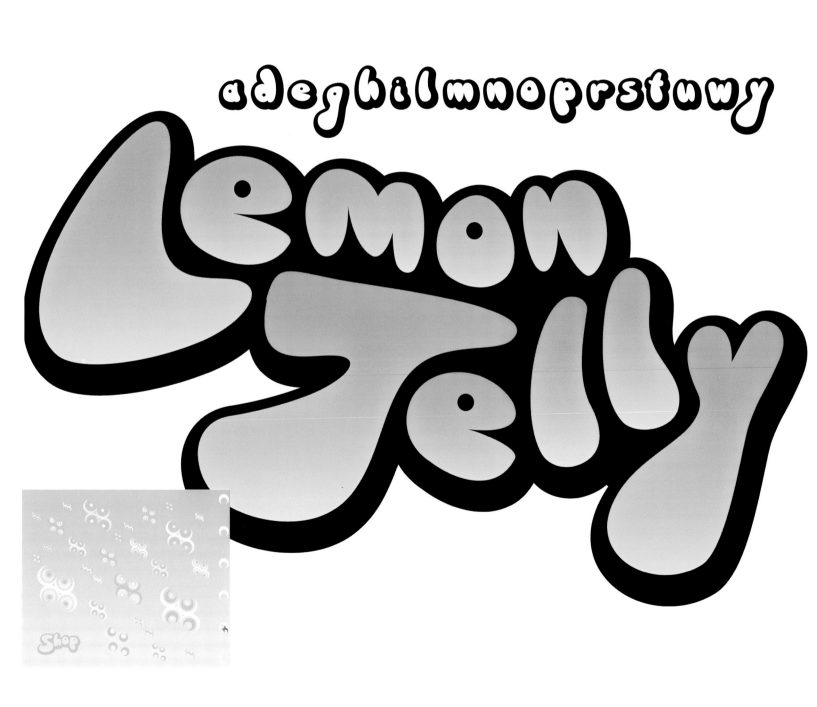

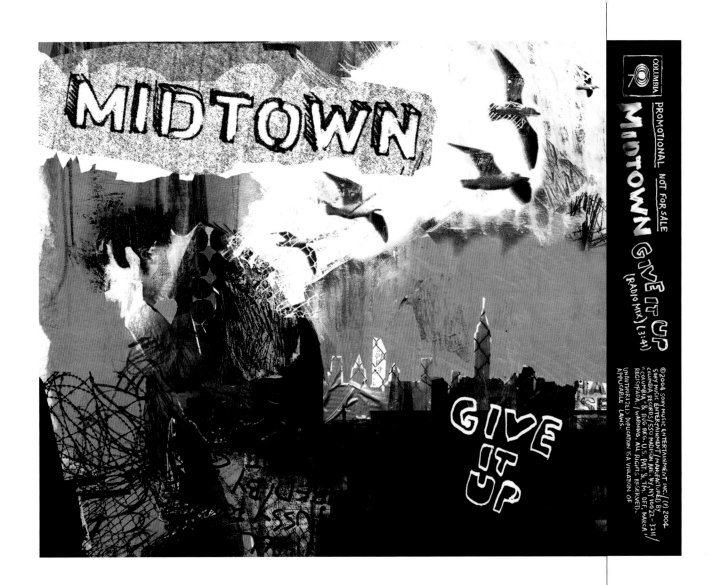

92

DESIGN
LINDA ZACKS

PROJECT
GIVE IT UP CD PACKAGE

92/93 CHAPTER 06: CONTACT
TYPE SPECIFIC MUSIC WWW.EXTRA-OOMPH.COM

Give it Up, the title of a single by U.S. band Midtown, reflects a recurring theme within the album from which it is taken, *Forget What You Know*. This and many of the songs on the album are about the dissolution of the lines of reality and the realization that things are never what they seem, that before we can understand the true nature of all things, we need to let go of whatever notions we have of them. The world then becomes clear and things begin to show themselves for what they really are, both good and bad. When Columbia Records commissioned Linda Zacks to design the CD package in 2004, she was given this information to interpret in her own way. They wanted the design to be original and cohesive, but also to specifically relate to the record's lyrical content.

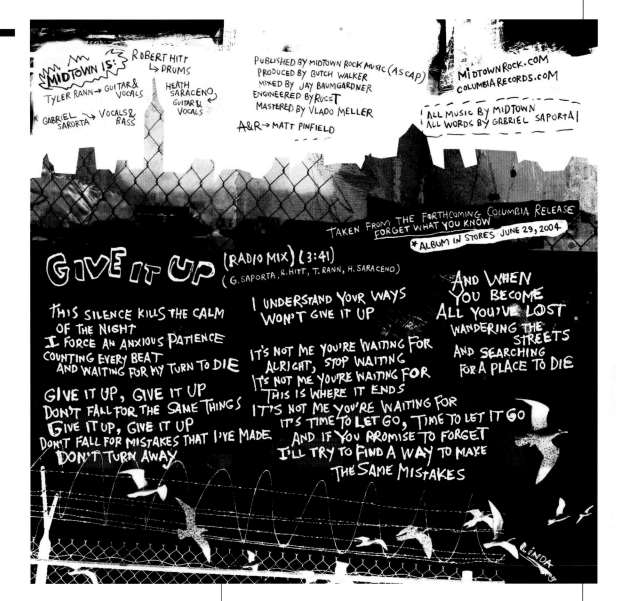

SOLUTION

"The concept opens up a range of possibilities, focusing on unearthing people's inner demons," explains Zacks, "and I approached this project with the album title and that concept firmly in mind." In addition, the band comes from the New York area and their name, Midtown, is also that of a well-known area of Manhattan, so Zacks wanted city imagery to feature prominently on the cover.

Zacks often uses type within her work, and has done so here. She created the band's logo by modifying type from a $2 plastic stencil; Zacks used a variety of other writing implements—quill and ink, ballpoint pen, thin marker—to achieve different textures in the lettering on the front and back covers.

"My type is purely instinctive," explains Zacks. "I seldom edit or change it. It's really whatever flows out of my pen, or quill, paintbrush, pencil, or crayon, and I revel in the smears and smudges and inconsistencies that make each letter unique. I love the idea of 'every letter different'."

However, for this project it was important that the type was legible and that it integrated well with the images: it was there to tell a story that the viewer had to read. The idea was that they got an intimate and personal feeling when viewing the designs, which is why the hand-drawn look of Zacks' type works. It is, of course, not quite a typeface in the true sense of the word, but it is a great example of the creativeness and expression of feeling that the design of lettering can offer.

Keepintime: A Live Recording is a film that documents the initial meeting and subsequent jam sessions between Los Angeles' session drummers and the turntablists/DJs who sample their recordings. Tamashiro wanted to create a typeface that would somehow reflect this hybrid of two generations linked by the same sounds. Much of the influence behind the design of this typeface, named Mochilla, came from the warmth of woodblock types, and its inconsistencies. However, Tamashiro added characteristics to his typeface to aid its functionality in new media forms, such as video and Web usage.

Because of this, there were extra considerations that had to be taken into account in its design. "In video I noticed that a lot of fonts tend to bleed, especially in the counters and bowls," explains Tamashiro. "They get distorted from horizontal/vertical hold settings and screen sharpness/ resolution. I added little notches at joints in the letterforms to compensate for screen bleed. It's very similar to the way Bell Centennial is designed to compensate for ink bleed on porous paper, and when set at small point sizes."

Mochilla was developed in Illustrator and imported into Fontographer, but because it is only an uppercase typeface there were a lot less characters to deal with than usual in terms of time and labor. It has been applied to print material—offset and screen printed on apparel—as well as in video and computer interfaces. It works very well across all the different platforms and helps create a distinct identity for the Keepintime project, without being overly stylish.

94

DESIGN
SOAP DESIGN CO.

PROJECT
KEEPINTIME: A LIVE RECORDING
CD AND DVD PACKAGE

CONTACT
WWW.SOAPDESIGN.COM

BRIEF

Mochilla is a Los Angeles–based production company formed by photographers B+ and Eric Coleman. It functions as an umbrella company under which they release their various photographic, film, and music projects. When Keith Tamashiro at Soap Design, also Los Angeles–based, was commissioned to create a package for this CD and DVD release in 2003, he was not asked to create a custom typeface, but he felt the project needed it.

ABCDEFGHIJKLM
NOPQRSTUVWXYZ
1234567890/
= :;.,..." " ''!?%.$¥£
NO. * ™ ¢ + × · @ ©®℗
ÁÉÍÓÁÚ ÊÎÔÂÛÑ

MOCHILLA A MOCHILLA FILM

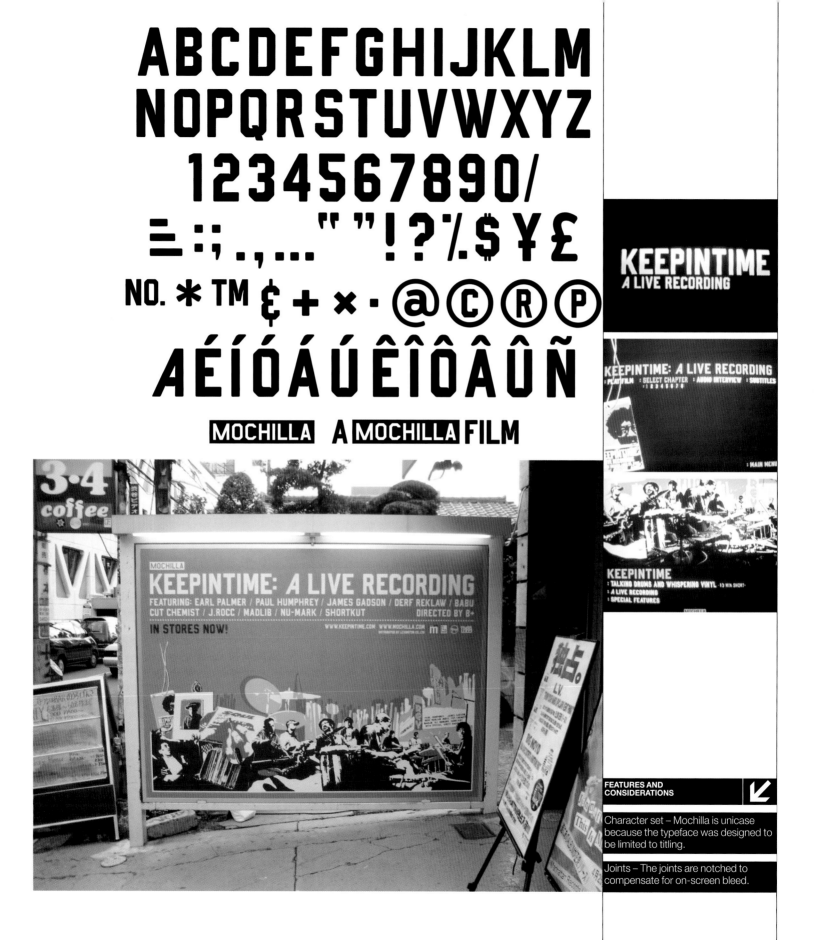

FEATURES AND CONSIDERATIONS

Character set – Mochilla is unicase because the typeface was designed to be limited to titling.

Joints – The joints are notched to compensate for on-screen bleed.

Together, letterheads, business
cards, and other items of
stationery—compliments slips,
envelopes, and so on—show how
designers can make the most of
what is essentially a fairly limited
area in which to work. Certain
criteria have to be met, in terms
of both form and content, when
designing a company's stationery;
it has to contain essential
information, be functional, and be a

LETTERHEADS AND
BUSINESS CARDS

CHAPTER 07

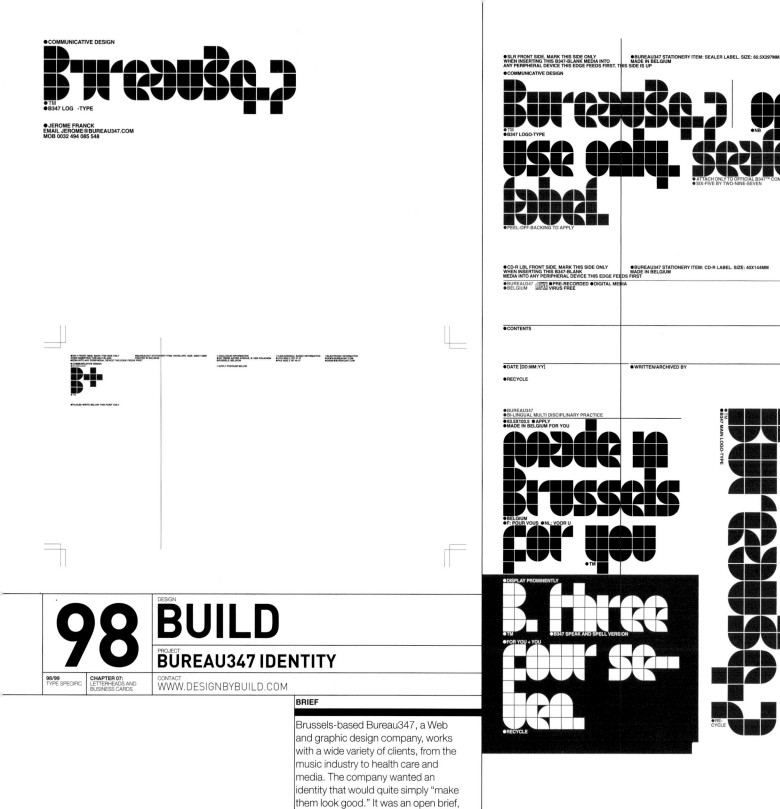

● COMMUNICATIVE DESIGN

● TM
● B347 LOG -TYPE

● JEROME FRANCK
EMAIL JEROME@BUREAU347.COM
MOB 0032 494 085 548

● SLR FRONT SIDE. MARK THIS SIDE ONLY ● BUREAU347 STATIONERY ITEM: SEALER LABEL. SIZE: 60.5X297MM
WHEN INSERTING THIS B347-BLANK MEDIA INTO MADE IN BELGIUM
ANY PERIPHERAL DEVICE THIS EDGE FEEDS FIRST. THIS SIDE IS UP
● COMMUNICATIVE DESIGN

● TM
● B347 LOGO-TYPE

● NB

● ATTACH ONLY TO OFFICIAL B347™ COMMUNICATION
● SIX-FIVE BY TWO-NINE-SEVEN

● PEEL-OFF-BACKING TO APPLY

● CD-R LBL FRONT SIDE. MARK THIS SIDE ONLY ● BUREAU347 STATIONERY ITEM: CD-R LABEL. SIZE: 40X144MM
WHEN INSERTING THIS B347-BLANK MADE IN BELGIUM
MEDIA INTO ANY PERIPHERAL DEVICE THIS EDGE FEEDS FIRST
● BUREAU347 ● PRE-RECORDED ● DIGITAL MEDIA
● BELGIUM ● VIRUS FREE

● CONTENTS

● DATE [DD:MM:YY] ● WRITTEN/ARCHIVED BY

● RECYCLE

● EN-V FRONT SIDE. MARK THIS SIDE ONLY ● BUREAU347 STATIONERY ITEM: ENVELOPE. SIZE: 220X114MM ● ANALOGUE INFORMATION ● CABLE/SIGNAL BASED INFORMATION ● ELECTRONIC INFORMATION
WHEN INSERTING THIS B347-BLANK PRINTED IN BELGIUM ● 347 RENE ASTRO AVENUE, B-1950 KRAAINEM ● VOX 0032 2 767 47 47 ● WWW.BUREAU347.COM
MEDIA INTO ANY PERIPHERAL DEVICE THIS EDGE FEEDS FIRST BRUSSELS, BELGIUM ● FAX 0032 2 767 40 47 ● DESK@BUREAU347.COM
● COMMUNICATIVE DESIGN
● BUREAU347 ● APPLY POSTAGE BELOW
● TM

● PLEASE WRITE BELOW THIS POINT ONLY

● BUREAU347
● BI-LINGUAL MULTI DISCIPLINARY PRACTICE
● 63.5X103.5 ● APPLY
● MADE IN BELGIUM FOR YOU

● BELGIUM
● F: POUR VOUS ● NL: VOOR U

● TM
● B347 MAIN LOGO-TYPE

● DISPLAY PROMINENTLY

● TM ● B347 SPEAK AND SPELL VERSION
● FOR YOU + YOU

● RECYCLE

● RE-
CYCLE

BRIEF

Brussels-based Bureau347, a Web and graphic design company, works with a wide variety of clients, from the music industry to health care and media. The company wanted an identity that would quite simply "make them look good." It was an open brief, and Michael C. Place of Build, London, was hired on the back of another project that he had done for them— the branding of an international graphic design exhibition.

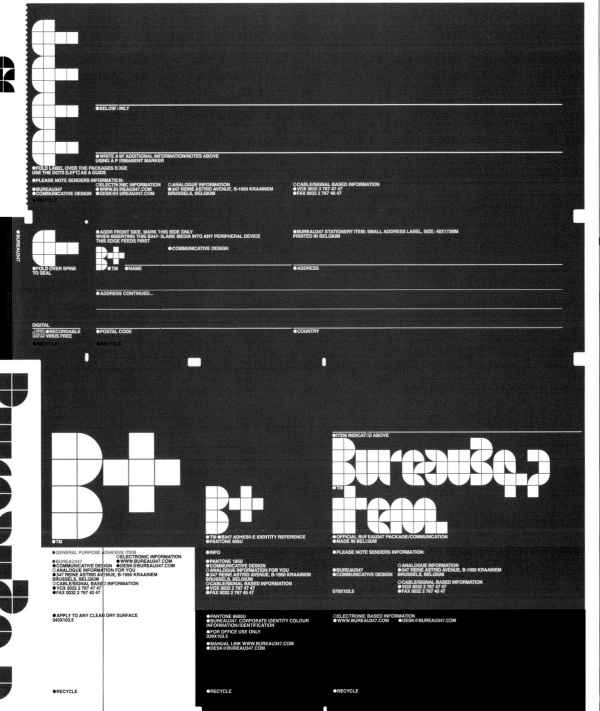

SOLUTION

"I wanted to create something that had a really nice, sensuous curve to it," explains Place, "almost the opposite of the cold, hard world of the pixel medium that the company mainly works in." The design was inspired by Bureau347's pink hairline logo, which represents the company's "continuing, never-ending thirst for the perfect solution in all types of communicative projects," and began around the letter B, as Bureau347 wanted a "trademark" in the form of B347. Readability was the main issue, and the design has certainly met that demand. This very intriguing and highly noticeable typeface works effectively on all the material it is has been applied to and gives the company standout.

This typeface is intentionally simple and friendly. Place wanted it to have a childlike, playful quality. Bureau347 is a young company and the font reflects its character—approachable and not too serious.

Michael C. Place of Build is represented by This is Real Art, London.

FEATURES AND CONSIDERATIONS

Design – The typeface has a modular design to reflect the modular nature of building Web sites, and to convey the idea of infinite possibility for shape/form from a simple building-block approach. This also gives it great flexibility.

Application – The font was animated in a puzzle-like way, to enable it to be taken apart and used on-screen in a pixel-friendly way.

c alm

abcdeFghijKLmnopqrstuuwxyz 1234567890
the quick brown fox jumps over the Lazy dog
abcdeFghijKLmnopqrstuuwxyz 1234567890
the quick brown fox jumps over the lazy dog

h ostile

abcdeFghijKLmnopqrstuuwxyz 1234567890
the quick brown fox jumps over the lazy dog
abcdeFghijKLmnopqrstuuwxyz 1234567890
the quick brown fox jumps over the lazy dog

a gitated

abcdeFghijKLmnopqrstuuwxyz 1234567890
the quick brown fox jumps over the lazy dog
abcdeFghijKLmnopqrstuuwxyz 1234567890
the quick brown fox jumps over the lazy dog

100

DESIGN
EGGERS AND DIAPER
PROJECT
BUSCHOW HENLEY ARCHITECTS IDENTITY

100/101 TYPE SPECIFIC	CHAPTER 07: LETTERHEADS AND BUSINESS CARDS	CONTACT WWW.EGGERS-DIAPER.COM

o utraged

abcdeFghijKLmnopqrstuuwxyz 1234567890
the quick brown fox jumps over the lazy dog
abcdeFghijKLmnopqrstuuwxyz 1234567890
the quick brown fox jumps over the lazy dog

s kizoid

abcdeFghijKLmnopqrstuuwxyz 1234567890
the quick brown fox jumps over the lazy dog
abcdeFghijKLmnopqrstuuwxyz 1234567890
the quick brown fox jumps over the lazy dog

Diaper began the project by talking to the architects about the practice's approach to architecture, its problems, goals, and so on, to get a feel for the company and its working methods. After many conversations two main points emerged, and these became the basis for the idea behind the identity and new custom typeface. The primary theme was architecture as abstraction; the secondary theme, the company's constant problems with getting paid. "We set out to design a face that would become increasingly abstracted and realized that it also had the potential to communicate the exasperation we feel when clients don't pay, or ignore, invoice reminders," explains Diaper.

The main outcome of this approach was that, instead of designing a type family that came in a series of weights, Diaper designed one that, rather unusually, comes in degrees of irritation. The five degrees available are: Calm, Hostile, Angry, Outraged, and Schizoid.

Together, the first letters of each "degree" spell Chaos. This provided the inspiration for the typeface's name—News Chaotic. Calm is a clearly legible bitmap-based face; as you progress through the degrees, each letter explodes from the center, becoming more broken down and illegible. However, the typeface occupies the same amount of space in each degree, meaning that as the individual elements of each letter migrate outwards, they collide and merge with elements from the letters to the left and right, and from above and below.

The ascenders in News Chaotic are relatively short compared with the descenders. In many instances, it is these "extenders" that define one lowercase character from another. Depending on the typeface, a and d, h and n, l and i, etc, can be confused if the extenders are too short. For News Chaotic Calm, the designers made sure that these letter pairs had different shapes to begin with so that the ascenders weren't the only aspect that distinguished one letter from the other, and this meant that pronounced ascenders weren't necessary. However, they kept the descenders longer to add texture.

The typeface needs quite wide kerning to work effectively. The counters and junctions get thrown out from degree to degree, and this creates larger white spaces, intended to represent growing irritation. Illustrator and Fontographer were used to create the typeface.

It really is quite an imaginative, unusual font family based on a solid and original idea. Diaper points out that when people are shouting, or angry, what they are saying isn't necessarily particularly clear; reflecting this, the face becomes less and less legible as the degrees increase.

London, may 22

dear matthew,

it was great to see you all the other day. i hope you all managed to get back ok - it always takes so long from richmond! i thought i'd let you know that we are looking into the hydraulic aspects of the roof structure and since this really belongs to stage 2, we'd appreciate payment or an advance on our original invoice if possible. susan sent this four weeks ago.

best wishes,

London, august 18

matthew,

could you look into this payment issue immediately..?

the invoice is extremely overdue and non-payment is seriously

102 WILLIAM HALL DESIGN

DESIGN

WILLIAM HALL DESIGN

PROJECT
PHIL REYNOLDS IDENTITY

CONTACT
WWW.WILLIAMHALL.CO.UK

BRIEF

Phil Reynolds is a well-known and respected U.K. costumier. He designs and makes bespoke, and often elaborate costumes for film, opera, ballet, television, and musical theater. In 2004, having been in the industry for over 20 years, he decided that a revamp of his own identity was in order, and commissioned designers William Hall and Nicholas Barba at William Hall Design to create a visual system for use on his stationery.

"We wanted to have something of his working processes in the design of his stationery," explains Hall, "so we began by collating various objects and images with which to work while sketching ideas of the design." This evolved from the idea of embroidered letterforms, but it was not intended to be a direct pastiche of embroidered typography— it had to be a little more sophisticated. Although the letterforms relate to the shapes made when type is sewn rather than printed, a careful interpretation demonstrates that a typeface based on the idea of a craft can also be uniform, modern, and practical. "Typefaces with a standard width line throughout design themselves," adds Hall. "You establish a set of criteria for each junction, and then carry this through. The aim then is to ensure that there are no rogue elements that will alter the 'color' of the type when it is set as a piece of text."

The typeface, named Phil Reynolds, has been applied to Reynolds' stationery, signage, and Web site, all designed by William Hall design.

Phil Reynolds
Costumes

Studio 44
Pennybank Chambers
33–35 St. John's Square
London EC1M 4DS

Telephone 020 7253 0678
Facsimile 020 7608 2133
Mobile 07973 327 647
email@philreynolds.com
www.philreynolds.com

VAT No. 480 8595 09

Phil Reynolds
Costumes

Studio 44
Pennybank Chambers
33–35 St. John's Square
London EC1M 4DS

Telephone 020 7253 0678
Facsimile 020 7608 2133
Mobile 07973 327 647
email@philreynolds.com
www.philreynolds.com

DAAM architects and designers formed in 2004 through the merger of two established architects. For its launch, they required a new "look." The brief to NB: Studio was to create something that was more modern than either architect's previous identity; something with a refreshing feel that would appeal to a younger, edgier client. However, erring on the side of caution, DAAM did not want anything so drastic that it might scare its substantial existing client base, built up over years, and disturb the reputation they wished to maintain.

104

DESIGN
NB: STUDIO

PROJECT
DAAM IDENTITY

CONTACT
WWW.NBSTUDIO.CO.UK

SOLUTION

"We felt that it was necessary to create a mark that looked solid and assertive, to reflect the established background of DAAM," explains Jodie Wightman at NB: Studio. "This was also fundamental to the nature of their business where, as a client, you want to be assured that this is a serious, trustworthy company to work with." Wightman and her team began to research the language and style of architecture and the drawings and ephemera that accompany it before beginning to work on the design. The typeface itself is based on Fregio Mecano, a font that Wightman found in a type book published by Redstone Press. An Italian typeface of the 1920s, by an unknown designer, all of its letters and numerals can be made using combinations of 20 segments. Because of its segmentation and architectural nature (you have to "build" each letter), NB: Studio felt it provided a perfect base for a typeface for the DAAM identity.

Like Fregio Mecano, the typeface NB: Studio created is composed of different segments that can potentially be rearranged and rebuilt for other uses. Where the segments join to form a letter, this is expressed as a white line; vertical white lines create a pattern that unifies the letter. It is possible to create a serif alphabet simply by adding segments, and letters can be created to occupy any space. The real genius is that, from 20 pieces, an infinite number of alphabets can be created.

The typeface has been applied to all stationery elements and is used in the DAAM logotype. The logotype is printed with thermographic ink which becomes raised when heated, adding texture to the blocky letters.

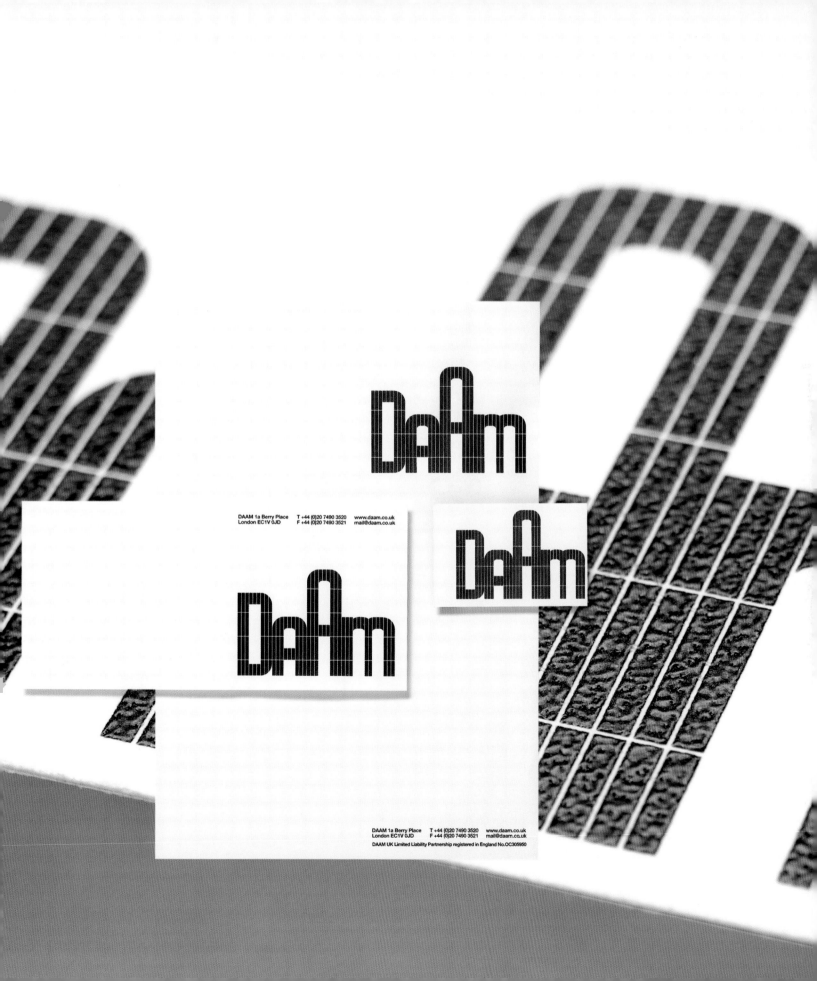

DAAM 1a Berry Place T +44 (0)20 7490 3520 www.daam.co.uk
London EC1V 0JD F +44 (0)20 7490 3521 mail@daam.co.uk

DAAM 1a Berry Place T +44 (0)20 7490 3520 www.daam.co.uk
London EC1V 0JD F +44 (0)20 7490 3521 mail@daam.co.uk
DAAM UK Limited Liability Partnership registered in England No.OC305950

106

DESIGN
WILLIAM HALL DESIGN

PROJECT
WE NOT I IDENTITY

CONTACT
WWW.WILLIAMHALL.CO.UK

BRIEF

We Not I is an architecture practice. In 2004, it commissioned William Hall Design to interpret the following text, in two dimensions, for a new company identity. "We are the oedipal offspring of the archifraudulent first person singular me-me-me nomadic fugitive formless multitudinous. We stalk the future without maps. We have dispensed with ourselves and consign our flotsam to the void. We traverse territories. We do not clique. We are free of prostheses parasites poetics. We were the consenting minors raped at the vanity fair. We are tired of the tyranny of irony the back pedalling book pedalling consumptive ego parade. We are precise not prescriptive. We do not fulfil institutional requirements our reality has no degrees of scale. We she he are the diatribe sublimaire like Bruce Lee 'we are all styles and no style'."

SOLUTION

We Not I is an "anonymous" architectural office in that it has an unpeopled central London office which houses a computer server from which its international operatives down- and upload files. The members of We Not I never have their names published and are not known in the public domain. This stems from their previous experiences at major architectural studios and a frustration with the idea of "architect as celebrity." It was from this that the designers drew most of their inspiration for the identity, wanting to demonstrate this invisibility and something of We Not I's approach to architecture. Further inspiration came from cardboard box batch numbering and NASA's ceramic shuttle panels.

The typeface was not designed on a grid and when you look at individual details—such as the way the diagonal downstroke of the N meets the vertical strokes—it can look a little strange. However, when seen as a whole, one does not read the irregularities, but instead sees an architectonic, timeless, tactile collection of letterforms. One of the reasons for this was that the holes could be neither too close together nor too small because of the process used; the typeface is only ever punctured, not printed, whether that be onto a letterhead, CD sleeve, or business card. "We have stipulated that the font can only be used reversed out, or by puncturing the material," explains Hall. "In this way, the font is notable in its absence rather than its presence. In puncturing the holes, we were making sculpture, making something that people might have a physical response to. Something that relied on light and touch and was playful."

Place wanted to create an "intricate typeface that was 'chunky' at the same time," to reflect the technical nature of Saccenti's photography. Inspired by the typefaces on an old Sony Betamax cassette, Place approached the design with the idea that it should have the natural flow of a handwritten letterform, but in a different way—more angular and with a computer-generated look. "It had to be decipherable, but I wanted to make the reader work, concentrate a little more than usual on the face, to engage the reader," explains Place. "Personally, I think it works most effectively when you see it in a large block, as the letters interact with each other really well." The font was created using FreeHand MX and FontLab.

Michael C. Place of Build is represented by This is Real Art, London.

BRIEF

Timothy Saccenti is a well-known, New York–based, international photographer. In 2003 he commissioned designer Michael C. Place, of Build, London, to create an identity for him. Knowing his work well, Saccenti gave Place a completely open brief for the project.

hello my name is
please see
over for further
information.

CARD Business-card.

UP ITEM: Wi Hi
NY / USA NAME 3.3in 2.165in SUR:NAME
LOGO IDENTITY: timothy saccenti
photography
150 forsyth st no. 5a
new york, new york
usa 10002
+001 917-475-4615
ADDRESS

107

DESIGN
BUILD

PROJECT
TIMOTHY SACCENTI IDENTITY

CONTACT
WWW.DESIGNBYBUILD.COM

FEATURES AND CONSIDERATIONS

Setting – The font was designed to be set with no leading so that the ascenders and descenders form an interlocking block. As the font has an almost monospace quality, the letterforms interact nicely when set in a block.

Characters – The characters show a definite uniformity of construction, as some were reused to make others— the n was flipped to make the u, the m flipped to form the w. This gives the font the clean look that was desired.

FRONT Letterhead/Invoice. TOP UP
NY / USA NAME SUR:NAME
IDENTITY: timothy saccenti
photography
150 forsyth st no. 5a, new york, new york
usa 10002 +001 917-475-4615
timothy@timothysaccenti.com
start here
CHOOSE START

lln/nnu

FOLD

The Latrobe Regional Gallery in Victoria, Australia, was established in 1970 to house works that focus on Australian art post 1971. It has a reputation for innovative exhibitions, and holds works by such prolific Australian artists as Jessie Traill, Evelyne Symes, and Ann Montgomery. In 2003, Melbourne-based 3 Deep Design were asked to create a new identity for the gallery that "captured the notions of community and its interaction with the arts."

108

DESIGN
3 DEEP DESIGN

PROJECT
LATROBE REGIONAL GALLERY IDENTITY

108/109
TYPE SPECIFIC
CHAPTER 07:
LETTERHEADS AND
BUSINESS CARDS
CONTACT
WWW.3DEEP.COM.AU

SOLUTION

The key to the typeface is a vertical line that represents this notion of "community." A requirement of the typeface is that all of the letterforms need to be aligned with this, giving the sense of a consistent grid in the background. Diagonals have been kept to a minimum to create a sense of repetition which, in turn, creates a sense of unity, again based on the main idea of "community." "We started by exploring notions of community, what it is that makes a community and how the individual fits into the framework of a community," explains Brett Phillips at 3 Deep. "We started with how an individual is represented in the most basic manner— point, or a line—then moved on to how a group of individuals form a community—by repetition of the individual element."

As the typeface had to be applied across a range of media including signage, stationery, advertising, and other printed material, the individual strokes of each letter were kept relatively simple in order to avoid problems in its application; the design team had to ensure that the weight of the strokes, and their relationship to one another, would hold up under all production methodologies and all applications. The only difficulty proved to be in ensuring the measure of sentences, due to the "awkward" spaces between letterforms. However, these open spaces, together with the simplicity of the design, give the typeface a calming, neutral voice.

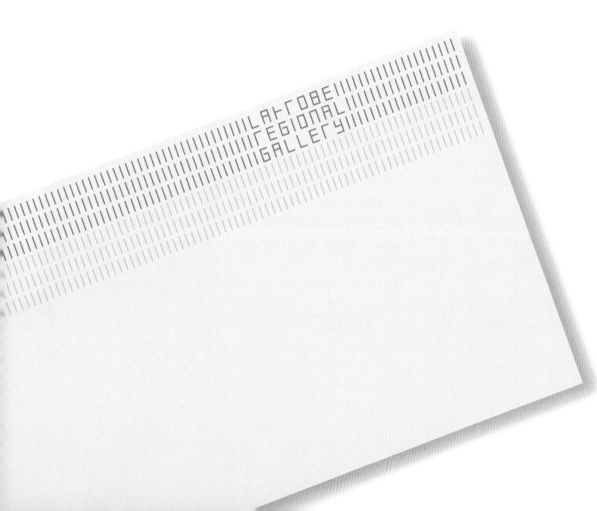

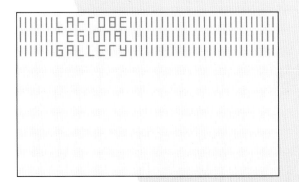

SCREEN (TV, FILM, VIDEO, WEB)

VT)

FILM

VIDEO, WE

CHAPTER 08

Creating type for use on-screen also provides designers with some very specific technical challenges. There are certain ingrained rules: use faces with a large x-height (this allows the use of smaller sizes without the text becoming unreadable), and avoid typefaces with finer serifs (they do not translate well on-screen). There are also a number of considerations not relevant in print design—speed and movement of type, lighting, and combining visuals with sound. Beyond this is a more fundamental issue to consider—the experience of the reader and the context in which they are viewing the type; printed type is read, moving type is watched.

The advent of cinema, and then television, meant that for the first time type, imagery, and movement were combined. For silent movies this was in the form of subtitles, and these developed into the more creative title sequences. Freed from the world of print, type was able to move, to be animated, to become 3-D. The iconic work of Saul Bass for such films as Psycho and Vertigo is still imitated the world over. However, the industry has changed massively since then. With computer technology, the constraints faced by Bass (he had a choice of hot-metal or hand-drawn faces) have disappeared and computers are used to combine digital type with clever graphics. Today, highly advanced computer-graphics programs allow for type to be manipulated in any way, and designers are making the most of this.

112 MONKEY CLAN

DESIGN

PROJECT
SOUTH WEB SITE

CONTACT
WWW.MONKEYCLAN.COM

Image-wise, the idea was to tie the different photographs together, so the designers applied a style treatment to the images, which included hand-drawn illustrations and a painterly process, intended to give the band a rough, raw, street attitude. They then used old design elements to tie in the classic look of the band's logo. Type-wise, the designers wanted to do something a little different, so they created a hand-drawn face to give the site and the band a sense of the immediate and loose. The letterforms are block-shaped, but set askew in keeping with the carefree layouts and raw images. This caused some problems with a few letterpairs, so the spacing was adjusted, and some letters were made smaller in order to "fit" with their neighbors. Once set in the layout, 3-D perspective lines were added to each letter; this gives the typeface a retro feel. "We wanted to make the most direct typeface possible," explains Kai Pham of Monkey Clan, "so we used all caps, block type. We welcomed the inaccuracies of mistakes while creating free-form letters because they all contributed to the charm."

In order to be used on the Web, each letterform was drawn in Illustrator before being imported into Flash, where they were animated.

BRIEF

South released their album *With the Tides* in 2003. To promote this release, New York–based design house Monkey Clan was commissioned to create a Web site. The designers were given the band's logo, album cover, and a number of band photographs to work with. The objective was to capture the attitude of the band and their music without making the site simply a brochure of the album cover, since it needed to last beyond that particular album.

Working on the 'g'

A. B. C. D. E.
g gg ggggg ggg gg

cage big egic ᴬ·

cage big egic ᴮ·

cage big egic ᴄ. FINAL \

cage big egic ᴰ·

cage big egic ᴱ·

114	DESIGN **ERIK JOHAN** **WORSØE ERIKSEN** WITH PLAY/UNION DESIGN
	PROJECT **GIN & PHONIC CD PACKAGING AND** **PROMOTIONAL VIDEO**

114/115 TYPE SPECIFIC	CHAPTER 08: TV, FILM, VIDEO, WEB	CONTACT WWW. PLAYPUPPY.COM / WWW.UNION.NO

et uvwxyzøæ
tuvwwxyyzøæ

£¥$ 1¿ 123456789 Å BCDEFGHIJK LM NOPQRSTUVW XYZÆØ
£££¥ⒶⓎ ¿¡23456789 Å BCDEFGHIJKKLM NOPQRSTUVW XYZÆØ

A. B. C. D. E.

BRIEF

Tweeterfriendly Music is a Norwegian band signed to Warner Music. The band consists of three composers/producers and a singer, Leslie Ahern. Its music is best described as classic pop, a style of music for which they all have a passion. In 2002, following a series of collaborations on various other projects, design agency Play/Union Design, also Norwegian, was asked to design CD packaging for Tweeterfriendly Music's album *Gin & Phonic* and to develop a concept for the band's promotional video for the release of the single "Undertow."

SOLUTION

Designer Erik Johan Worsøe Eriksen decided to use the typographic element from the CD cover within the video. With video's coarse resolution, fine, detailed typefaces do not work well, so it was important that the overall shapes of the characters were simple while still conveying a distinct image.

"Because of the way I wanted to animate the type, I needed a genuine Monoline to start with," explains Eriksen. "I wanted to be able to chop the characters into small 'drops' and to easily alter the thickness of the line, so my first thought was to merely modify an earlier typeface I'd made."

Eriksen began modifying his Kit Ideal typeface, but in fact ended up creating a whole new one—Friends. Friends is based on a set of geometric modules; only a few characters deviate from the underlying scheme. It is a no-nonsense face that combines the coolness of nonemotional, mechanical designs with the organic, visually harmonic and lively rhythm of humanistic typefaces, and because it is based on a single line with no change in thickness, it works well animated on-screen.

 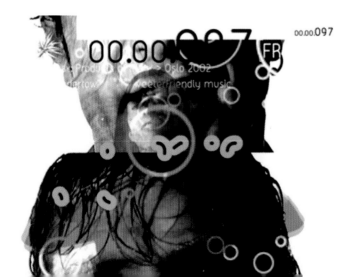

EACH OF THE 10 SKATERS MAKES THREE 75-SECOND RUNS WITH EACH OF THE SIX JUDGES GIVING A WHOLE NUMBER 100-POINT SCALE FOR TWO RUNS. OF THE SIX SCORES GIVEN BY THE JUDGES, THE HIGHEST AND LOWEST SCORES ARE DROPPED AND THE FOUR SCORES LEFT ARE

116

DESIGN
BRAND NEW SCHOOL

PROJECT
FUEL TV ON-AIR IDENTITY

CONTACT
WWW.BRANDNEWSCHOOL.COM

BRIEF

Fuel TV, a subsidiary of Fox Cable Networks, is a network devoted to action sports and the cultures surrounding them. In 2003, the network commissioned New York design house Brand New School to create typefaces for part of its on-air identity project. The brief to the designers was to create an "antibrand," acknowledging that the Fuel TV audience is a deeply suspicious one, and knowledgable about marketing strategies.

SOLUTION

Designer Jens Gelhaar responded to the brief by avoiding consistency, and any hints of corporate graphic design, as much as possible. Five typefaces were created for the identity: four were adapted from existing faces while one, Fuel Square, was created from scratch by Gelhaar. All five are set in uppercase only, with default tracking, which suggests e-mail or vinyl lettering.

To enable the letters to be animated easily, the five fonts were resized to the same cap height, and the tracking was equalized: this makes them interchangeable. Arial, FF Elementa, PP Derrida, and Frankfurter are the four faces that Gelhaar chose and adapted. He created Fuel Square as he wanted a "squarish punk thing or a Grecian sports font, or better yet, a combination of the two.

The idea was to mess up the stereotype of an American Football font," he explains. "I drew a Grecian alphabet and threw in some irregularities to the treatment of the angles and the basic skeletons. I added a layer of squarish Punk lettering, resulting in a lighter weight, a wider stance." Gelhaar worked directly in Fontographer rather than on paper when designing the face. By mixing influences and creating an inconsistent typeface, the five Fuel faces represent what action sports are all about. Even more so, Fuel Square is intended to work in context with the other four "Fuels." The faces have been used on-screen, in print ads, and on Web sites.

FUEL™

SIGNATURE SERIES
NO 1 OF 100:
SAIMAN CHOW

ARIAL BOLD 23pt 0% TRACKING

HAMBURGEFONTS 0123456789
ABCDEFGHIJKLMNOPQRSTUVWXYZ
SKATEBOARDING

FUEL GENERIC 24pt 0% TRACKING

PP DERRIDA 24pt 0% TRACKING

HAMBURGEFONTS 0123456789
ABCDEFGHIJKLMNOPQRSTUVWXYZ
SKATEBOARDING

FUEL STENCIL 24pt 0% TRACKING

ELEMENTA BOLD 23.5.pt 8% TRACKING

HAMBURGEFONTS 0123456789
ABCDEFGHIJKLMNOPQRSTUVWXYZ
SKATEBOARDING

FUEL MONO 24pt 0% TRACKING

FUEL 24pt 0% TRACKING

HAMBURGEFONTS 0123456789
ABCDEFGHIJKLMNOPQRSTUVWXYZ
SKATEBOARDING

FUEL SQUARE 24pt 0% TRACKING

FRANKFURTER MEDIUM 26pt 0% TRACKING

HAMBURGEFONTS 0123456789
ABCDEFGHIJKLMNOPQRSTUVWXYZ
SKATEBOARDING

FUEL ROUND 24pt 0% TRACKING

FEATURES AND CONSIDERATIONS

Asymmetry – The asymmetric rendering of the letters A, M, V, W is a departure from traditional Grecian styles, and while O is drawn with diagonal corners, characters that should be related, such as C, G, S, U, are square, without any diagonals.

Angles – Other small 45° shapes in B, D, P, Q, R maintain the characteristics of Grecian types, although there is much inconsistency between, say, B and R.

"Y" – The Y, one of the characters that features angular strokes in any orthodox type design, is drawn with only horizontals and verticals.

NO NEED TO GET UP.
WE'LL BE RIGHT BACK.

NEXT:
BLIND: "VIDEO DAYS"
(S. JONZE + K. WINTHROP, 1991)

SEASON
PREMIERE

to cultivate

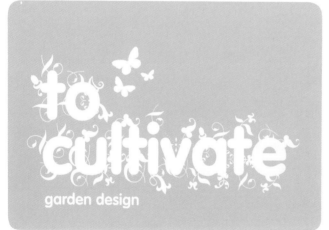

to cultivate

VAGRounded – Black

+

Botanical MT

=

to cultivate
garden design

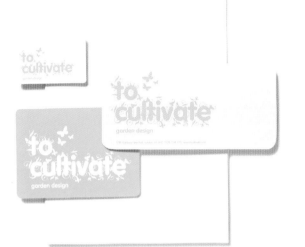

To Cultivate, a landscape gardening company, commissioned NB: Studio to design an identity that they could apply to a range of stationery (including business cards, compliments slips, and letterheads) press folders, and van livery. To Cultivate wanted an identity that had a modern feel while maintaining traditional elements.

NB: Studio has not so much created a new typeface as combined two existing faces. Having researched the whole concept of gardens, the designers wanted to create an identity with a logo using a typeface that appeared to be "growing." The font created is primarily Vag Rounded bold, and the florals and other decorative shapes "growing" from the letterforms are borrowed from Botanical. The element of growth is particularly effective on the company's Web site, where the type has been animated.

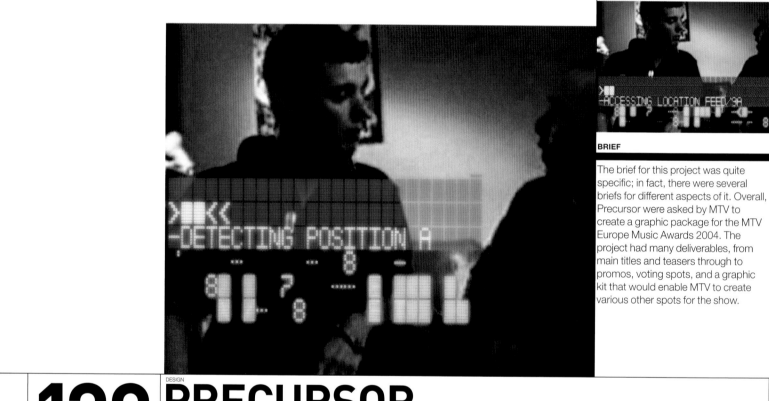

BRIEF

The brief for this project was quite specific; in fact, there were several briefs for different aspects of it. Overall, Precursor were asked by MTV to create a graphic package for the MTV Europe Music Awards 2004. The project had many deliverables, from main titles and teasers through to promos, voting spots, and a graphic kit that would enable MTV to create various other spots for the show.

120 DESIGN
PRECURSOR

PROJECT
MTV GRAPHIC PACKAGE FOR MUSIC AWARDS 2004

CONTACT
WWW.PRECURSORSTUDIO.COM

The overall creative solution was based around an underground street race in Rome; the main titles for the awards show this race in full. The street footage was shot in Rome and cars were added later. For on-screen information used during the awards, the designers created a navigation system that would be used by the drivers during the race. The system continues the underground feel, but is also relatively hi-tech; a glitchy esthetic was created so it almost appears that the feed is not transmitting properly.

For this system the designers created a custom font based on a grid. The font needed to work well on-screen and be easy to animate. Television screens have quite a low resolution and because of this, there are minimum point sizes for type to ensure readability in a TV environment. In addition to this, TV works with two fields, upper and lower, and a line will flicker on and off as it doesn't encompass both fields, so a specific minimum width is required: a one-pixel line is likely to flicker.

The grid for the typeface was designed in Illustrator and the font created in FontLab. After Effects was the main tool used to animate the type, which has mainly been used on-screen as part of animations for the TV information system.

Precursor built the font, named ASCII, specifically for the type of animations they were creating. It forms the basis of a lo-fi ASCII system with an underground "coded" feel. Building the lowercase letters as scrambled letterforms and the uppercase as unscrambled ensured that it would work well with the animation techniques they were using.

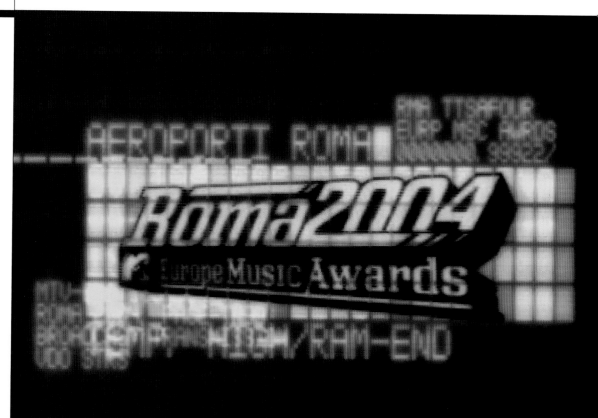

Character widths – As the font needs to conform to a tight grid, it is monospace; every letter has the same width.

Work on the identity began in early 2004 and was completed in time for the TV Channel's launch in October that year. Base wanted to express the idea of a "human" TV—that a TV has a mind and spirit of its own. They tried to achieve this 'human personality' through the design and use of typefaces. The messages are written in a typewriter font and signed with a "signature logo" that looks hand-drawn.

The principal typeface in the identity is based on ITC American Typewriter, a humanist, warm typeface. This went against the then current trend of using cold sans-serif or bold typefaces in broadcast applications. A typewriter font was the obvious choice for the designers at Base: they believe that a face that comes from the typewriter best expresses the idea of "a message from a person."

The original idea was to have a version of American Typewriter Monoline: this face has very little contrast and no ornamentation in the serifs, which makes it more readable in a broadcast environment. However, as the font was to be used in many different ways— everything from text in a magazine to on-screen animation—the designers wanted to strike a balance in characters that could work in these various contexts.

Illustrator was used for sketching the typeface and FontLab 4.6 used for its production: FontLab's scripting capabilities allow the user to program their own scripts to perform many different operations. This allows more precision in the design and production processes through checking letterpairs, spacing, and so on.

The designers at Base also used a library called RoboFab, which adds more capabilities to the FontLab scripting environment.

122 BASE

PROJECT
BETV IDENTITY

CONTACT
WWW.BASEDESIGN.COM

BRIEF

In 2003, media and communications giant Vivendi Universal sold a number of affiliates of one of France's biggest pay TV channel providers, Canal+. This led to the Belgian version of Canal+, Canal+ Belgium, being relaunched as BeTV. Base was asked to create an overall corporate identity for the new channel, including print and screen applications. The brief specified that the "spirit" of Canal+ (contemporary, exclusive, and unique) was kept, but that the "look" of the new identity be a complete departure from that of Canal+.

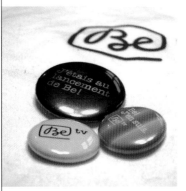

abcH23
abcH23
abcH23
8Q&

abcdefghijklmnopqrstuvwxyz
ABCDEFGHIJKLMNOPQRSTUVWXYZ
0123456789 /?!&+$*Ç"

American Typewriter Be tv Light

abcdefghijklmnopqrstuvwxyz
ABCDEFGHIJKLMNOPQRSTUVWXYZ
0123456789 /?!&+$*Ç"

American Typewriter Be tv Regular

FEATURES AND CONSIDERATIONS ↙

x-height – Slightly taller than the original American Typewriter in order to give more white space in the counters and through this, increase legibility when printed in small sizes, or when viewed at low resolution on screen.

Cross sections – These were made geometric to follow the idea of a straightforward, uncomplicated monoline face.

Counterspaces – The counterspaces were made open to avoid them filling in on screen.

Counters – The counters are less round than is usual in order to have as much white space as possible inside every character, without losing the original look of American Typewriter.

séries

2

télévision

foot? foot!

typogr

22:45

programmes

Film

Be tv

CHAPTER 09

BOOKS AND CATALOGS

The modern history of type began with the printing of books during the fifteenth century. Credited to German Johannes Gutenberg, the invention of movable type is recognized as one of the most important developments in recent history in terms of the potential and opportunity it provides.

Gutenberg's celebrated bible (circa 1444) is widely held to be the first printed book. Printing processes, design, and typefaces have changed somewhat since then, but the layout and format of books has remained pretty much the same. The most obvious requirement of a typeface used within a book is legibility. It is essential that the words are easily readable which is why, traditionally, serif typefaces are used: serifs help carry the reader's eye along the line and on to the next word. In most books published today, the body text will still be set in a serif typeface, but the design of book covers is becoming a real art, almost like posters, giving designers that blank canvas on which to work with text and imagery.

As with newspapers and magazines, the design of books and catalogs usually requires both headline and body text. When working in this area of design, legibility is the number one issue.

BOOKS AND CATALOGS

126

DESIGN
HJÄRTA SMÄRTA

PROJECT
SCANDINAVIAN SPARKS VISUAL PACKAGE FOR EXHIBITION

126/127
TYPE SPECIFIC

CHAPTER 09:
BOOKS AND
CATALOGS

CONTACT
WWW.WOO.SE

CARIN RODEBJER

Carin Rodebjer is one of the most successful new names within Swedish fashion.

The label Rodebjer is about renewal and contradiction. The collections are inventive but elegant and classic, feminine with a masculine touch and free from trends but still modern. Focus is on the silhouette, the cut flows with motion and liveliness. Carin says that she wants to encourage women to adapt her clothes to their individual lifestyle. There is a concern that the label Rodebjer should add to the dignity and integrity of the wearer. Carin Rodebjer is represented in cities such as New York, Paris and Tokyo. For *Check in* Carin Rodebjer has packed a suitcase of garments inspired by Asia, Africa and the city of New Orleans.

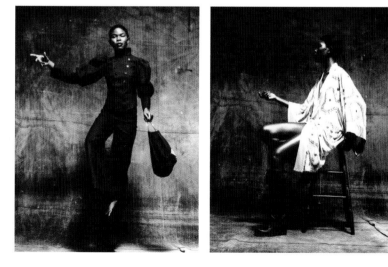

Left page: *Rodebjer Fall 2003* Right page: *Rodebjer Fall 2004* Photo: *Thomas Klemensson*

129

Sauna, a Swedish-based exhibition company, and curator Susanne Rolf, organized an exhibition of work by Swedish artists and fashion designers. Titled Scandinavian Sparks, this was held at gallery 798 Space, in Beijing's Dashanzi Art District, in 2004. For the exhibition, Sauna and Rolf needed a visual concept to include the design of a catalog, posters, invitations, and business cards, and a custom typeface for the exhibition displays.

The design of the typeface was inspired by the name of the exhibition, which conjures up ideas of sparkling stars and snowflakes. By cutting out a large number of small paper shapes, including stars and diamonds, Hjärta Smärta created a whole new visual language for the exhibition.

"We thought of those paperworks that children make; the kind where stars and shapes are cut out. You see them in lots of Swedish kindergarten windows," they explain. "Visually, the paper stars are familiar to most Swedes, but the idea of cut paper also made us think of Chinese paperworks, which connects with Beijing."

Letters were formed by combining the "confetti" left from cutting out these shapes, and a complete type-face was eventually created. It was too complicated to position all the individual paper pieces in the scanner in order to form the face in Photoshop, so forms were drawn in Illustrator and the letters put together from these. The result is a stylized version of the "confetti letters," creating a font that is eminently more readable.

The cover of the catalog has a cut-out star with a colorful spinning wheel behind it; when this spins, it gives the impression that the star is sparkling, as all the different colors are seen through the holes. Stars have been used throughout the catalog, in the headline font on each of the artist's pages, and to indicate the start of a new chapter.

This is a typeface that has a strong element of fun. It combines handcraft with the computer to great effect. The only issue is that it cannot be used as body text—used small, the confetti shapes become blurred and difficult to read—but then that is not what it was intended for.

A B C D E F
G H I J K L
M N O P Q R
S T U V W X
Y Z Å Ä Ö

RocaWear is an "urban" clothing label set up by Damon Dash and Jay Z, both of legendary hip-hop record label Roc-A-Fella Records. In 2003, New York–based designer Giovanni Russo, owner and Creative Director of No11, proposed the idea of designing a book as an alternative marketing tool for the label; something that was a bit different, to reflect the nature of the RocaWear brand.

128

NO. 11 INCORPORATED

THE ROC

SOLUTION

As Russo himself put it, the inspiration behind the design of this extravagant, lavish, and luxurious book was the subject matter and Damon Dash's lifestyle. Dash has established himself by running highly successful businesses within the music and fashion industries and achieving a cohesive link between the two. With this book, which includes supermodel Naomi Campbell among others, Russo wanted to take the link one step further. He created this decadent, Gothic-style font especially for the project. Set within the pages of the book, it creates a fantastic juxtaposition and an exciting energy between the ornate and old-fashioned, and the more glamorous bling nature of today's hip-hop.

Creative Director: Giovanni Carrieri Russo
Designer: Dennis Ortiz Lopez

abcdefghijkl
mnopqrstuv
wxyz

"This
is
Only
the
Beginning."

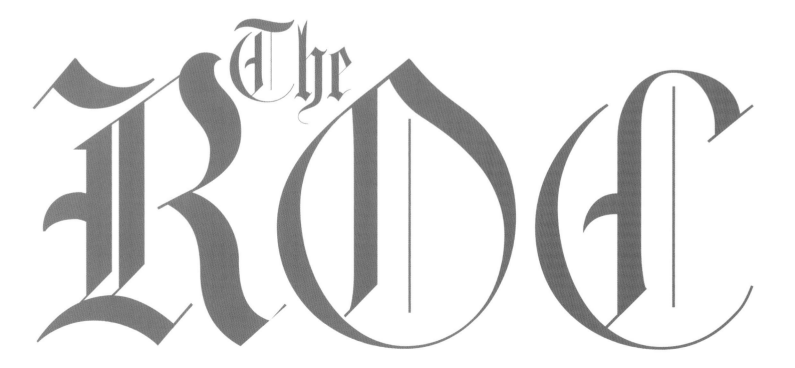

The
ROC

design & approach

feedback

abcdefghi

jklmnopqr

stuvwxyz

BRIEF

The Interaction Design Research Studio at the Royal College of Art, London, works on a variety of studies. One of these, the Equator project, is a six-year, interdisciplinary study that investigates the interweaving of the physical and digital worlds by developing innovative systems. The studio focuses on new technologies for the home and has designed and built three pieces of electronic furniture and furnishings: a coffee table, a hall table, and a tablecloth. In 2003, Hyperkit was asked to create an information booklet for the studio, entitled *Electronic Furniture for the Curious Home*, announcing their findings to date.

SOLUTION

The designers at Hyperkit were given a large amount of the research material to work with—sketches, diagrams, photographs—and they used this material to inform the design. They wanted to find a visual solution to link the three products—coffee table, hall table, and tablecloth—so picked up on their electronic aspect; the tablecloth contains circuits that light up when an object is placed on it.

They developed a typeface with letters that could be joined together, to suggest electronic connections. Called Output, it was derived from the circuit diagrams that feature on the tablecloth. Laid out in a grid, every letter has a circular "connector," and where an ascender and descender follow the same line, they have been extended so that a circular "connector" links the two. Output is used as a display font only. Throughout the booklet the letters for each heading have been assembled individually in order to allow them to be joined vertically as well as horizontally. The font was created in Illustrator.

furniture in context

history
tablecloth

electronic
furniture
for the
curious
home

Letterforms – The same basic shape, and angular features, were used for each letterform to reflect the grid of an electronic circuit.

Ascenders – Some letters that don't usually have ascenders, including a, c, o, were given short "extensions" at a 45° angle so that they could be joined to other letters.

Decoration – Small circles, "connectors," were added to each point where letters met to convey the notion of electronic connections.

who
we
are

key
table

drift
table

ABCDEFGHIJK ABCDEFGHIJK ABCDEFGHIJK

<table>
<tr><td>DESIGN</td></tr>
</table>

132	DESIGN **CHANGE IS GOOD** RIK BAS BACKER, JOSÉ SOARES DE ALBERGARIA, AND MARCO MÜLLER	
	PROJECT **FRAC PACA BOOK DESIGN**	
132/133 TYPE SPECIFIC	**CHAPTER 09:** BOOKS AND CATALOGS	CONTACT RIKBB@WANADOO.FR

Christophe
Berdaguer &
Marie Péjus

Negative
architecture/
Black Block

As well as the design and layout of the artists' work within the book, a typeface was needed for use on the cover and inside. Bas Backer and Albergaria, in collaboration with Marco Müller, adapted and updated a typeface that they originally developed in 2002, but had left unused as the original client rejected it. Inspired by color, mosaic, Paulo Canto (Portuguese writer, typographer, publisher, and printer), Joseph Albers (Bauhaus artist, teacher, and typographer), and printing techniques applied by constructivist artists, the typeface, named Zérik, is almost a work of art in itself. It is built up from five different layers and colors that complement one another. Each layer can be produced in a different color to create, when all five are fitted together, a mosaic.

Different combinations produce completely different versions of the type, and the angular shapes of the letters make it look as if each square has been laid by hand, like a mosaic. It is a delightful typeface.

ZÉRIK est une police conçue par José (Zé) Albergaria et Rik Bas Backer. Elle a toujours été refusée par différents commanditaires. Cet ouvrage est l'occasion de lui donner une première lisibilité, bien qu'elle n'ait pas été conçue pour être lisible.

BRIEF

The *Frac Paca* book is a collaborative arts project between the Centre National de l'estampe et de l'art Imprimé (CNEAI), Fonds Régional d'Art Contemporain (FRAC) of the Provence, Alpes, and Côte d'Azur regions in France (PACA), and was financially supported by Espace Paul Ricard. CNEAI organizes exhibitions and other special arts projects in France, FRAC PACA coordinate regional government funds for contemporary arts projects, and Espace Paul Ricard finance and generate contemporary art projects. In 2003, French designers Rik Bas Backer and José Soares de Albergaria were commissioned to design a book showcasing rejected works by contemporary French artists.

In 2001, Base was commissioned to design a book on Belgian design that had been compiled by la Maison des Métiers d'Art (MMAP) and the VIZO Arts Foundation. *Made in Belgium Design Book* looks at both established and emerging Belgian designers, showcasing their work to present and promote contemporary Belgian design to an international audience.

The designers at Base wanted to create an extraordinary and special object that was not controlled exclusively by the images, but that had an identity as a design piece in its own right. The idea was to create a strong design concept built around a typeface. The typeface selected was Cointrin, created by Kimou Meyer, a Swiss graphic designer who was working at Base at the time. It was inspired by airport information panels—the name Cointrin is a reference to the Geneva airport of the same name.

"I was waiting for a plane in Geneva airport and I noticed the sign with the departure and arrival information," explains Meyer. "I always liked the retro look of it and the mechanical noise when the information changed. I shot some pictures in black-and-white, then scanned them and tried to match them as closely as possible in Illustrator with a vectorized Univers and some geometric shapes."

The font is a monospace, and works best when it is integrated into both a horizontal and vertical grid. Fitting the typeface to this simple grid is a reference to its original purpose; to directly communicate important information in a clear, organized way. It was important for Meyer to recreate the look communicated by the Swiss analog airport signage, but in a 2-D, paper context.

"Working with this 'airport typeface' unites the book as a whole and supports its purpose of presenting Belgian designers internationally," explains designer Thierry Brunfaut at Base. "It was quite easy to use as it is monospace, and with the different styles of the contributing designers, the neutral and mechanical nature of the typeface enabled individual designs to stand out, while providing uniformity to the book as a whole."

DESIGN
134 BASE

PROJECT
MADE IN BELGIUM DESIGN BOOK

134/135
TYPE SPECIFIC

CHAPTER 09:
BOOKS AND
CATALOGS

CONTACT
WWW.BASEDESIGN.COM

A O 1
MADE IN
BELGIUM
DESIGNBOOK
SELECTION
ABCDEFGHIJKLMN
OPQRSTUVWXYZ
0123456789!@&/

BRIEF

In the summer of 2004, Swiss designer Urs Lehni was commissioned to design a catalog for the graduation works of the visual communication department at the School of Art and Design, Zurich. The brief was fairly open creatively.

136 | DESIGN
URS LEHNI
PROJECT
SCHOOL OF ART AND DESIGN, ZURICH GRADUATION CATALOG

136/137
TYPE SPECIFIC

CHAPTER 09:
BOOKS AND
CATALOGS

CONTACT
WWW.OUR-MAGAZINE.CH

A.B.C.D.E.F.G.H.I.J.K.L.M.N.O.P.
Q.R.S.T.U.V.W.X.Y.Z.

a.b.c.d.e.f.g.h.i.j.k.l.m.n.o.p.
q.r.s.t.u.v.w.x.y.z..

1.2.3.4.5.6.7.8.9.0..;_-éöàäèü!$()/&%

24 PT.
The quick brown fox
jumps over the lazy dog.

SOLUTION

The typeface was inspired by an existing face, Learning, that was specially developed to help young children learn how to write. Lehni's idea is based on the contradiction in "graduation" being seen as the end of a person's period of learning, with the need for a person to continue learning whether studying or not. As Lehni modified an existing typeface, the design process didn't take that long.

The original typeface was developed out of basic geometric shapes, and Lehni worked with these. He tightened up the spacing, using Adobe Illustrator and FontLab, to make his version a monospace font. The new typeface is called Almost Monospaced, as the W takes double the space of every other letter. It has been used in the catalog and on the invitation card. In addition, a stencil version of the font was produced so that the letters could be applied directly onto the wall at the graduation exhibition.

Over the following pages, a number of "special" typefaces, created to fulfil a more unusual or unique brief, or for use on unusual or unique materials, are examined. For instance, Natascha Frensch's Read Regular typeface was created specifically for dyslexics. This particular project demonstrates how designing a typeface for a specific audience or job makes you look at the characters in a different manner and raises questions regarding their appearance, the pros and cons of the typeface, and so on. Read Regular has helped raise awareness of the issues surrounding dyslexia.

Similarly, Digital Signage for Transport looks at how different audiences benefit, or suffer, from the way type is used in digital signage, and how problems within this area can be overcome.

BRIEF

Freelance designer Angela Pelzl created these typefaces in response to an open brief while she was studying an MA in Communication Design at Central Saint Martins College of Art and Design, London. At that time Pelzl was specifically interested in creating objects that involved printed fabric, collage, and manual fabrication. Having decided upon the topic "Gender," Pelzl needed to create a typeface that she could use on her intended series "Insulting Cushions" and "Haberdash on Skin."

140

DESIGN
ANGELA PELZL
PROJECT
INSULTING CUSHIONS AND HABERDASH ON SKIN

140/141
TYPE SPECIFIC

CHAPTER 10:
SPECIALS

CONTACT
WWW.CIRCLETDESIGN.COM

AaBbCcDdEeFf
GgHhIiJjKkLlMm
NnOoPpQqRr
SsTtUuVvWw
XxYyZz , . ~

Bellend
Dickhead
Dickwad
Fuckwit
Knob
Knobend
Knuckledragger
Pecker
Prat
Prick
Pussy
Tosser
Twat
Wanker

*MALE = STRAIGHT

In short, the project addressed gender-related issues and gender-specific crafts. The four small pink cushions listed numerous English swear words, divided into four gender-specific groups: male hetero, male gay, female hetero, and female gay. The Haberdash and Haberdash Shadow typefaces were created to apply those words to the cushions. A simple serif font served as a template, and the choice of a white thread on white fabric resulted in a subtle look. Creating this typeface through embroidery saw Pelzl use a needle and thread as a design tool instead of a mouse or a pen.

Pelzl transferred the outlines of the template typeface onto fabric and then, after experimenting with several embroidery techniques, settled on the stem stitch. As an addition to this bitmap font, Pelzl also created a TrueType character set made only from the shadows of the original font. She did this by digitizing the bitmaps using Photoshop, FreeHand, and Fontographer. The letters of the bitmap font have to be placed individually by hand for each project, using only the naked eye and guidelines. "The mixing of manual work with digital manipulation is something that interests me," explains Pelzl. "The work gains a surface feel, and imperfection adds charm and character."

The typeface was applied to silk for the Insulting Cushions project, using a transfer sheet called Lazertran. The TrueType typeface requires extreme simplification of the rendered shadows: Fontographer can only import shapes with a limited number of angle points. Also, each letter had to be scanned, level adjusted, rendered, and altered before positions and counterspaces could be dealt with. The bitmap typeface had to be set in a grid and freed of its original background through masking in order to adjust to any chosen light background.

"Experimentation and the reintroduction of a craft in my own visual language was my main idea with this project," explains Pelzl. "I felt my design was dominated and limited by the usage of the computer, by the flat, digital perfection that is at the core of it, and since my topic dealt with gender roles and gender-specific manners, I wanted to practice and embed a feminine activity such as embroidery in my project."

Butch
Carpetqueen
Dyke
Fuzzmuncher
Lezza
Muffdiver
Rugmuncher

*FEMALE = GAY

Bitch
Brazenhussie
Cow
Cunt
Dog
Ho
Slag
Slapper
Tart
Trollop
Twist

*FEMALE = STRAIGHT

Assbandit
Bender
Chocolatespeedwayrider
Chocolatestarfishkisser
Faggot
Fudgepacker
Gaylord
Mattressmuncher
Nonce
Ponce
Poof
Puffer
Queer
Sausagejockey
Shitstabber
Spermfarter
Uphillgardener

*MALE = GAY

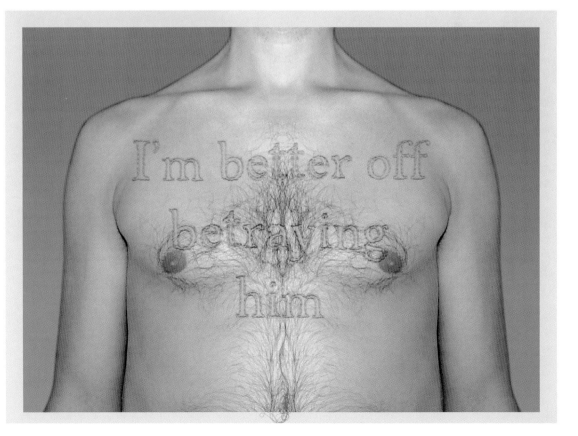

It is estimated that, in the U.K. alone, there are over 2,000,000 severely dyslexic individuals, including some 375,000 schoolchildren, while in the U.S., dyslexia affects over 40,000,000 individuals. Dyslexia is independent of intellectual ability and teaching, and of socioeconomic and language background. In recent years there have been a number of computer software innovations developed to combat dyslexia, especially for children. However, relatively little design research has been done in the area of typography and typefaces that might support dyslexics, and that is where Dutch graphic designer Natascha Frensch comes in with her self-initiated project to create a typeface that would offer such support. Sponsorship for this came from the AudiDesign Foundation and Deutsche Bank Pyramid Award.

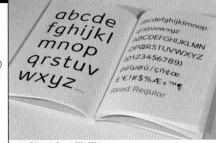

0123456789

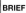

142

NATASCHA FRENSCH

PROJECT
READ REGULAR TYPEFACE TO SUPPORT DYSLEXICS

CONTACT
WWW.READREGULAR.COM

SOLUTION

Frensch's own difficulties with dyslexia were the main inspiration behind the project, but she also wanted to help others suffering from the same problems and frustrations. She began by researching dyslexia and traditional type design, looking at the idea of creating 26 individual characters as opposed to the basis of traditional typeface design in which two or three set the forms for all other characters.

"Dyslexia is about coping with left, right, up, down, and so on," explains Frensch. "Shapes that contain the exact same mirrored shape create confusion, so I wanted to see what would happen if the 26 alphabetical characters weren't created by copying, pasting, and mirroring."

Four years in the making, the typeface Read Regular aims at preventing a neglect of dyslexia, creating a more confident feeling regarding the problems that occur as a result of it, and providing a possible solution to sufferers' reading difficulties.

Frensch worked in FontStudio and Fontographer to create this typeface. Initially it was used in *My Friend has Dyslexia*, an educational publication from Chrysalis Children's Books, and *Dyslexia and Dyspraxia*, a support guide for The Royal College of Art, London. Since then, Frensch has collaborated with the College in using Read Regular for many of their educational titles.

Not only is Read Regular a technically sound typeface, it has also generated a much-needed awareness about dyslexia. The fact that this is one of the very few typefaces designed for a certain audience shows that this is an area of potential growth. By designing Read Regular, Frensch has tried to change prejudice and ignorance regarding the difficulties that occur with dyslexia, and to help those suffering from its effects.

FEATURES AND CONSIDERATIONS

Characters – The most significant aspect of Read Regular is the fact that it is based on 26 individual characters, and within those characters there are other highly considered elements that make up the typeface (outlined below).

Counters – Kept open to prevent them from closing in visually or due to printing.

Cross strokes – Given a considered length to ensure that they are noticed, but kept short enough to prevent them interfering with the previous or following character.

Crossbars – Placed so that the countershape is open enough to prevent closing in.

Ascenders – These have a considerable length, but have been kept short enough to prevent them interfering with the line above.

Descenders – These have a considerable depth and are shaped so that they will not visually disappear; e.g., the j has a distinct finial.

Junctions – As Read Regular has a solid character and does not show an extreme variety of widths, the junctions all have an even weight.

Spacing – This is fairly generous in order to prevent certain pairs from causing confusion, e.g., making sure that the pair r and n could not be mistaken for an m.

Arms – The arms were given an equal length in order to create a solid image: this helps prevent the appearance of the character jumping.

Tails – The Q has an obvious tail, so as not be mistaken for an O.

Bowls – The bowls for every character are made individually, to make each one distinct.

Loops – The g has not been given a loop as this is a feature that can cause mistakes and lead to confusion. To maximize clarity, it has been given a strong finial instead.

Spurs – Again, these have been given a considered length to make them visually strong, and thus make the letter distinct.

Width – Characters are fairly wide to ensure that they are read individually and do not clash.

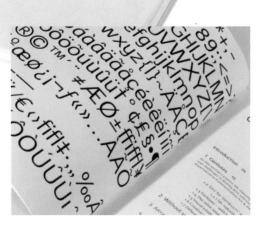

FOR MORE EFFECTIVE READING AND WRITING

While this typeface was not designed for a client, I felt it was worth including for its unusual design values and the innovative idea.

DESIGN
144 BOND AND COYNE ASSOCIATES

PROJECT
PERSONAL PROJECT

CONTACT
WWW.BONDANDCOYNE.CO.UK

SOLUTION

Created in 2001 by Bond and Coyne Associates, this is the Fold typeface. Inspired by something that the designers spotted one day skirting the edges of an old shop window—security tape—what was a traditional form of security became a material from which to create a typeface.

Metallic security tape relies on a continual flow of electricity, and it is that which forms the basis of Fold. The designers began experimenting with the tape, folding it in one continuous piece to create words and sentences. "We had to make sure that the letters of the typeface were formed without breaking this circuit," explains Martin Coyne, Director at Bond and Coyne. This meant that the designers were restricted in how certain letters could be formed, and in particular, how certain letters ran into their immediate neighbor. However, this constraint has led to an interesting switch of texture: the grain of the tape alters according to the direction in which it is laid down, which brings a 3-D quality to the surface of the type, particularly as it catches the light.

What is great about this typeface is that is only exists in a physical form, going against the norm of solely screen- or print-based typefaces.

...old is a typeface that only exists in the physical form.

it is not designed for screen or print as its aim is to be an integral part of a ... system

Display
Colour

departures	d
departures	d
departures	d

Display
Colour

departures	d
departures	d
departures	d

Display
Contrast

Departures	Departures
Departures	Departures
Departures	Departures
Departures	Departures

departures

DMR

departures

Rail Alphabet

departures

Helvetica

departing

departing

The project was inspired by what the designers at Roundel and the Helen Hamlyn Research Centre saw as an area of signage with great potential for improvement—transport signage. Displaying public information in an electronic format offers so much potential, particularly in a transport context where the information may need to change very quickly. Electronic displays offer a range of options for text presentation, layout, and color, and have the advantage of being able to show "real time" information.

For deaf and visually impaired passengers, electronic displays should be able to present more information, more clearly, and immediately. Roundel picked up on the fact that, in many cases, transport communication systems are designed for the benefit of the operators rather than in the interests of passengers. The result of this is that passengers have to work harder to understand how these systems operate, how to buy and use tickets, where to find the right connections, and so on.

Most digital signage uses pixel-based display systems such as CRT (cathode ray tube), TV monitors, plasma screens, or LCD (liquid crystal display) equipment. Another technology widely used in transport is the LED (light emitting diode) display. A new generation of LCD/matrix display is also available; this offers better daylight operation but, like the LED, only offers a bit-map level of font display.

Working closely with type designers Dalton Maag, the designers at Roundel created the DMR typeface to illustrate the principles of creating a range of letterforms that translate well in digital signage. Problems that arise from rasterization of a typeface in different operating systems, the limitations of low-resolution displays, and the requirements for the presentation of large type have all been taken into consideration. The typeface serves as an example of best practice in font design for digital application in a transport environment.

The DMR typeface has great flexibility in the size at which it can be used; it can be increased by 25 percent of x-height yet maintain the same length of text as that of more conventional signage typefaces. For digital display technology used in portrait mode, this is a particular advantage. Larger type means better legibility for many people, particularly from a greater distance.

BRIEF

The Helen Hamlyn Research Centre, based in the U.K., is dedicated to the study and practice of socially inclusive design. In 2003, for the Design Business Association (DBA) Design Challenge, which explores inclusive design through practical research and projects within the industry, Roundel began a project that looked at digital signage for transport. A key objective of the Design Challenge initiative is to demonstrate how a deeper understanding of the needs of users can be a driver for innovation within design. Through research the aim was to create a set of digital signage guidelines and a typeface aimed at a designer or transport manager who may be approaching digital signage for the first time.

FEATURES AND CONSIDERATIONS

Line length – DMR is more condensed than many currently used typefaces to allow for more information to be displayed in a constricted display space.

Weight – DMR is light in weight to ensure that counterspaces maintain their openness, which aids legibility and helps avoid any ambiguity.

Design – Compared with many fonts used in transport signage, DMR has its roots more obviously in humanist design. Even in its condensed state the characters retain their openness, clearly distinguishing a c from an o, for example.

Character definition – Characters such as b and d have been considered and designed for maximum difference. It is known that, in particular, the characters b, d, p, and q present problems of recognition for dyslexics. DMR also looks at the characters 1, I, and l (the number 1, the capital i, and the lowercase l) and ensures that with the slab-serif detail, they demonstrate some distinct differences to aid legibility and recognition.

Typography
DMR space

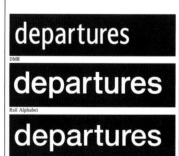

departures

DMR

departures

Rail Alphabet

departures

Helvetica

arriving	Departures
departures	Departures
departir	Departures
departures	Departures
departing	Departures

Departures Departures

Departures departures

departures departures

departures departing

departures departir

URCES

RESOU

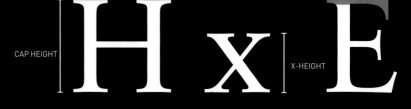

CAP HEIGHT | H | x | E — X-HEIGHT

SHOULDER | n | S — SPINE | G — SPUR

GLOSSARY

152

GL OS SA

ARM
An upper stroke attached to the letterform at one end and free at the other (compare leg)

BIT-MAP
A graphic image that is composed of dots. This term is also used to describe the on-screen representation of a font

COUNTER
The hollow space within a letterform

FONT
The complete character set of a particular typeface in a particular size and style. Originally spelt fount

LEADING
The space between lines, from one baseline to the next

ASCENDER
The part of a lowercase letter that projects above the x-height

BODY TYPE
The type that is used as "main" type, as opposed to headline type

DESCENDER
The part of a lowercase letter that hangs below the baseline

FORMATTING
Styling type to achieve the desired structure and appearance

LEG
a lower stroke attached to the letterform at one end and free at the other (compare arm)

BAR
The horizontal stroke that features in letters such as A and H

BOWL
The curved stroke that creates an enclosed space within a letter, as for B and P

EAR
A small stroke featured on the top right side of the bowl, typically on a lowercase g

HEADLINE TYPE
A type designed to be used in small amounts, as opposed to body text

LETTERPRESS
A form of relief printing using wood or metal type

BASELINE
A nonvisible line on which letters sit

CAP HEIGHT
The height of the capital letters, from the baseline to the top of the letter

FAMILY
A range of typefaces based around a central design, e.g. Arial Black, Arial Bold, Arial Rounded are all part of one family

KERNING
The adjustment of space between pairs of letters to improve the appearance of type

LIGATURE
A character consisting of two or more letters joined together

Diagram labels

ASCENDER · BOWL · BAR · COUNTER · EAR · LINK · DESCENDER · LOOP · SERIFS: BRACKETED AND UNBRACKETED

STEM · STRESS · STROKE · SWASH · SWASH · TERMINAL · TAIL

b A B e j g i i
L C N R Q t

LINK
A stroke that connects the top and bottom of a two-story, lowercase g

POINT SIZE
The unit of measure used for type; there are 72 points to the inch

SERIF
A small, decorative stroke at the end of a letterform

SPUR
A small projection often found at the end of the curved portion of the letters C, S, and G

SWASH
A more decorative or exaggerated form of serif

TYPE HEIGHT
The height of the physical wood or metal letter, from plate to face (not to be confused with x-height)

LOOP
This refers to the lower part of the lowercase g; it may be fully or partially enclosed. Fully/partially enclosed extenders of cursive letters are also called loops

POSTSCRIPT
Adobe Systems Inc. introduced this programming, or page description language in 1983. Type and images in PostScript format will output on a machine that has a PostScript interpreter

SHOULDER
The curved stroke in characters including h, m, and n

STEM
The main stroke in a character, usually vertical

TAIL
This refers to the curved descender of a Q, K, or R. The descenders on g, j, p, q, and y are also referred to as tails

UNICODE
An international standard for character sets

MONOSPACE
A typeface where each character is allotted the same space

ROMAN
A serif typeface; a typeface that is upright rather than italic

SLAB SERIF
A heavy, rectangular serif

STRESS
This refers to the direction of thickening in a curved stroke

TERMINAL
The end of a stroke that has not been finished with a serif

X-HEIGHT
A term used to describe the height of the main part of lowercase letters

OLD FACE
A term used to refer to typefaces that have an oblique stress

SANS SERIF
A typeface without serifs

SPLINE
The main curved stroke of the upper- and lowercase s

STROKE
A straight or curved line

TYPEFACE
A set of fonts

RY

CONTACT DETAILS

TA... C

3 DEEP DESIGN
WWW.3DEEP.COM.AU

A2-GRAPHICS/SW/HK
WWW.A2-GRAPHICS.CO.UK

AIRSIDE
WWW.AIRSIDE.CO.UK
WWW.AIRSIDESHOP.COM

**ANDREA TINNES/
TYPEKUT**
WWW.TYPEKUT.COM

**ANGELA PELZL/
JUST MY NAME**
WWW.CIRCLETDESIGN.COM

ASTERIK STUDIO
WWW.ASTERIKSTUDIO.COM

ATELIER WORKS
WWW.ATELIERWORKS.CO.UK

BARNBROOK DESIGN
WWW.BARNBROOK.NET

BASE
WWW.BASEDESIGN.COM

**BOND AND COYNE
ASSOCIATES**
WWW.BONDANDCOYNE.CO.UK

BRAND NEW SCHOOL
WWW.BRANDNEWSCHOOL.COM

BUILD
WWW.DESIGNBYBUILD.COM

CLARISSA TOSSIN/A'
WWW.A-LINHA.ORG

COREY HOLMS
WWW.COREYHOLMS.COM

CRAFTYFISH
WWW.CRAFTYFISH.COM

CYKLON
CYKLONGRAFIK.NET

**DENNIS ERIKSSON/
WOO AGENCY**
WWW.WOO.SE

EGGERS + DIAPER
WWW.EGGERS-DIAPER.COM

**ERIK JOHAN
WORSØE ERIKSEN/
PLAY/UNION DESIGN**
WWW.PLAYPUPPY.COM
WWW.UNION.NO

ERIK SPIEKERMANN
WWW.SPIEKERMANN.COM

**FABIO ONGARATO
DESIGN**
WWW.FODESIGN.COM.AU

**HANS SEEGER AND
JOHN SHACHTER**
HANSSEEGER@EARTHLINK.NE
T SHACHTER@SBCGLOBAL.NET

HANSJE VAN HALEM
WWW.HANSJE.NET

**HELENA
FRUEHAUF/2X4**
EMAIL: HELLIF@AOL.COM/
WWW.TWOXFOUR.NET

**HJÄRTA SMÄRTA/
WOO AGENCY**
WWW.WOO.SE

HORT
WWW.HORT.ORG.UK

HYPERKIT
WWW.HYPERKIT.CO.UK

**JENS GEHLHAAR/
BRAND NEW SCHOOL**
WWW.BRANDNEWSCHOOL.COM

**JEREMY TANKARD
TYPOGRAPHY**
WWW.TYPOGRAPHY.NET

KAI AND SUNNY
WWW.KAIANDSUNNY.COM

KARLSSONWILKER
WWW.KARLSSONWILKER.COM

KERR|NOBLE
WWW.KERRNOBLE.COM

THE KITCHEN
WWW.THEKITCHEN.CO.UK

**LINDA ZACKS/
EXTRA-OOMPH**
WWW.EXTRA-OOMPH.COM

NATASCHA.FRENSCH
WWW.READREGULAR.COM

NB:STUDIO
WWW.NBSTUDIO.CO.UK

NO11 INCORPORATED
WWW.NO11.COM

NON-FORMAT
WWW.NON-FORMAT.COM

MARK ERRINGTON
WWW.MARKERRINGTON.ME.UK

MILK
WWW.MILKCOMMUNICATIONS.COM

MODE
WWW.MODE-ONLINE.CO.UK

MONKEY CLAN
WWW.MONKEYCLAN.COM

OHIO GIRL DESIGN
WWW.OHIOGIRL.COM

ORANGE ITALIC
WWW.ORANGEITALIC.COM

PASCAL COLRAT
WWW.ART-CONTEMPPORAIN.
EU.ORG/COLRAT/INFOS/
ACCUEIL.HTML

PATRICK DUFFY
WWW.UTAN.CO.UK

**PETER BRUHN/
FOUNTAIN**

**PETER STITSON/
DAZED & CONFUSED**
PETER@CONFUSED.CO.UK
WWW.CONFUSED.CO.UK

PHIL BAINES
WWW.PHILBAINES.CO.UK

PRACTISE
WWW.PRACTISE.CO.UK

PRECURSOR
WWW.PRECURSORSTUDIO.COM

PRODUCTS OF PLAY
WWW.PLAYPUPPY.COM

RAFAEL KOCH
WWW.VECTORAMA.ORG
WWW.CHIDO.CH
WWW.ENCYCLOPAEDIZER.NET

RBG6
WWW.RBG6.SE

RICHARD NIESSEN/TM
WWW.TM-ONLINE.NL

RIK BAS BACKER
RIKBB@WANNADO.FR

ROUNDEL
WWW.ROUNDEL.COM

SAGMEISTER INC.
WWW.SAGMEISTER.COM

SATURDAY
WWW.SATURDAY-LONDON.COM

SOAP DESIGN CO.
WWW.SOAPDESIGN.COM

STEREO TYPE HAUS
WWW.STEREOTYPEHAUS.COM

SURFACE2AIR
WWW.SURFACE2AIR.COM

**SUZY WOOD/
DAZED & CONFUSED**
SUZY@MAKEREADY.CO.UK
WWW.CONFUSED.CO.UK

TERMINAL DESIGN
WWW.TERMINALDESIGN.COM

**TYPOGRAPHIC
MASONRY**
WWW.TM-ONLINE.NL

UNDERWARE
WWW.UNDERWARE.NL

UNFOLDED
WWW.UNFOLDED.CH

**UNITED DESIGNERS
NETWORK**
WWW.UNITEDDESIGNERS.COM

URS LENHI
WWW.OUR-MAGAZINE.CH

VAULT49
WWW.VAULT49.COM

WILLIAM HALL
WWW.WILLIAMHALL.CO.UK

INDEX

156

ACK
WLEDGM

ACKNOWLEDGMENTS

TYPE SPECIFIC COULD NOT HAVE BEEN PUT TOGETHER WITHOUT CONTRIBUTIONS OF WORK FROM ALL THE DESIGNERS FEATURED WITHIN IT, SO FIRST AND FOREMOST MANY THANKS TO THEM. THANKS ALSO TO THE TEAM AT ROTOVISION, PARTICULARLY LINDY DUNLOP, FOR ASSISTANCE IN COMPILING THIS BOOK, AS WELL AS TO THE TEAM OF DESIGNERS AT LOEWY WHO, ONCE AGAIN, HAVE DONE A FANTASTIC DESIGN JOB. I'D ALSO LIKE TO THANK XAVIER YOUNG AND LUKE HERRIOTT. A SPECIAL BIG THANK YOU TO JASON. THIS BOOK IS FOR MUM.

K
KN
NTS